PAGE STREET
PUBLISHING CO.

First published in 2017 by
Page Street Publishing Co.
27 Congress Street, Suite 105
Salem, MA 01970
www.pagestreetpublishing.com

Distributed by Macmillan, sales in Canada by The Canadian Manda Group.

22 21 20 19 12 13 14 15

ISBN-13: 978-1-62414-385-4
ISBN-10: 1-62414-385-7

Library of Congress Control Number: 2016962831

Cover design by Amy Latta
Book design by Page Street Publishing Co.
Illustrations by Amy Latta

Printed and bound in China

To Noah, the light of my life and the most wonderful thing I have ever played a role in creating. I love you the most.

And to you, reader. May these workshops inspire you and show that you are capable of more creativity than you ever thought possible.

CONTENTS

INTRODUCTION

Hello, friend!

Are you ready to begin a creative journey with me? I'm Amy, and I am so excited that you want to develop your lettering skills. While I share a variety of craft and DIY projects on my blog, oneartsymama.com, my absolute favorite art form is hand lettering, and I can't wait to share it with you. Hand lettering has become an increasingly popular art form over the last few years, and it's something that anyone can do. Maybe you're already artistic and just want to learn a new skill. Or perhaps you feel limited in the creativity department and have serious doubts about how successful you'll be. Let me promise you right now that by the end of this book, you will be creating beautiful designs. It's easier than you think. Honestly. Perhaps you're already skilled at hand lettering and are looking for inspiration. You'll find that here too, with more than 45 new designs to create. There's something in this workbook for everyone.

Hand lettering is an incredibly useful hobby. Once you master some basic skills, you'll want to use lettering to decorate everything from cards to wall art. It's also quite portable; you'll be able to create designs just about anywhere you go. I always travel with a brush pen in my purse, and I've been known to letter on whatever was available, including coffee cups and napkins. The best part, though, is that it can be a great way to relax and relieve stress as you go through the motions of forming a design. My hope is that you will find yourself enjoying every step of the process as you go.

Now, let's get started! I can't wait to show you some of my favorite lettering tips and tricks as you explore this fun and relaxing hobby.

HOW TO USE THIS BOOK

This workbook is divided into step-by-step workshops, each designed to teach you a new skill related to hand lettering. There's no experience required; we'll be starting together with the basics of faux calligraphy and you'll be getting increasingly advanced as you move through the skills. You can focus on one workshop each week, one each day or go at whatever pace you like. Throughout the lessons, we'll explore a variety of different font styles and embellishments, as well as the basics of brush lettering technique. Each workshop has a featured design you can create at the end and step-by-step instructions for the new skill. You can practice in the provided space right here in the book or in a sketchbook. There's also a special page at the end of each chapter where you can create your finished piece, or you can use it for more inspired practice.

In addition to lettering instruction, each workshop also has a themed paragraph that will act as a springboard for the quote you'll be lettering in the featured design. My hope is that reading and thinking about the theme will be one more way you can relax and engage with this hobby. I also hope it will give you an extra connection to the quotes you're lettering, making them meaningful art in addition to practice for your skills.

Are you ready to begin? As long as you have this workbook and a writing instrument, you can get started. Any pen, marker, or even a pencil will do at first, but there are definitely some materials you'll want to think about purchasing as you progress. Take a look at the supply list so you'll be prepared for the upcoming workshops.

Amy Latta

SUPPLY LIST

One of the great things about hand lettering is that you can create amazing art with very few supplies. If you have a good pen and a scrap of paper, you can letter just about anywhere. As you complete the designs in this book, here are the supplies you'll want to have on hand.

For Basic Lettering

These are the supplies you'll consistently need for every workshop.

- Soft Tip Brush Pen—I use the Tombow Fudenosuke
- Fine Tip Black Pens—I like the Sakura Pigma Micron Pens 01, 03, and/or 05
- Pencil
- Block Eraser
- Straightedge

For Colored and Dimensional Lettering

These pens allow you to create colored, shadowed and highlighted designs.

- Colored Markers—I highly recommend Tombow Dual Brush Pens
- Gray Marker
- White Gel Pen—I like the Sakura Gelly Roll

For Masking

- Masking Fluid (available in a bottle or pen)—I have the Molotow Grafx Masking Fluid Marker (refillable) 4mm

For Watercolor and Brush Lettering

- Water Brush (optional)—Mine is the Pentel Aquash
- Paintbrush, Script Liner Style, Size 10/0
- Watercolor Paints

For Embossing

- Heat Tool for Embossing
- Embossing Pen, Black or Clear
- Embossing Powder, your choice of color

EASIEST-EVER FAUX CALLIGRAPHY

Hand lettering encompasses a huge variety of styles and techniques, many of which we're going to look at together in the coming workshops! The most common style associated with it, though, is brush calligraphy. The actual technique of brush lettering takes a good bit of time and practice to master, and I promise we'll do just that a little later on in our time together. For now, though, to get started quickly, we're going to learn some very simple faux calligraphy. This will give you the look of brush lettering in just a few basic steps. Honestly, anyone can do it, and you'll be creating beautiful lettered art in no time.

it's "me time"

RENEW & RECHARGE

If your life is anything like mine, you spend so much of your time and energy taking care of the people around you that at the end of the day, there's very little left. Some of you have children at home who demand all of your time and attention. Some of you are caring for aging parents or sick relatives. All of us have responsibilities managing our homes, doing laundry, preparing meals and looking out for the interests of whomever is in our care. In the end, the many hats we wear can leave us feeling just plain worn out. The truth is, we need to make sure that in the midst of taking care of everyone else, we intentionally carve out time to care for ourselves too. If we keep on giving without ever recharging, we'll quickly find ourselves with nothing left to give. I know lots of women who feel guilty about taking time just for themselves, but the reality is that when we do, it makes us better wives, moms, daughters, sisters and friends. There are tons of different ways to take some "me time." The key is to intentionally plan it into our schedule. If we keep waiting for a free moment, it will never come. Instead, plan a certain time of day or a certain hour each week when you get uninterrupted time to do whatever energizes you. One great way to do this is by setting aside a specific time each week to reflect and allow yourself to be creative while following along with the prompts in this book. As we walk through a variety of hand-lettering techniques, don't focus on being perfect—enjoy the journey and let it be a relaxing experience that's just for you.

Let's dive into our first workshop!

FAUX CALLIGRAPHY WORKSHOP

Our first prompt is a simple one; we're going to letter the phrase "It's Me Time!" to remind ourselves that this hobby is our time to relax and recharge.

Let's begin by learning how to use faux calligraphy to write the word "time," then you can use those same skills to write the other words in the phrase. Ready?

STEP 1

Write the word "time" in cursive, leaving a little bit of extra space in between your letters.

Any type of marker will work for this, or even a pen or pencil if that's all you have on hand.

You can use as much or as little of a slant as you want, but I've noticed that most of the hand lettering I particularly like tends to be pretty much vertical. You can play around with it as you practice, but for starters, try making your letters straight up and down. Typically, I write my cursive letters continuously, without picking up my pen during a word to keep things looking smooth. While you don't want to rush through your lettering, keep your hand relaxed and moving at your normal writing speed, because moving too slowly can cause your lines to appear shaky.

STEP 2

Find the downstrokes and draw a second line next to them.

What's a downstroke? It's any place where your marker is moving in a downward direction when you naturally write the word. As you get more comfortable with the technique, you'll learn where these strokes are for each letter of the alphabet. Below, I've illustrated for you where those spots are in the word "time."

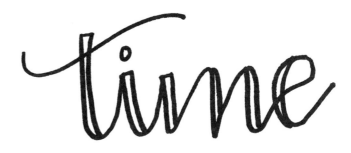

STEP 3

Fill in the double line areas with your marker to create the illusion of thicker lines.

In the process, you can make any little corrections you need to if some of your lines were shaky or not quite what you wanted.

9

That's all there is to it! Now it's your turn. Practice the word "time" in the space below. Don't be afraid to make mistakes. The key to learning lettering, like any other skill, is repetition, so just keep on trying over and over again. Let yourself be focused and calm as you practice; remember that this is a journey, not a race!

Are you ready to create your lettered phrase? Use the space on the next page to try all three words, "it's me time." You can arrange them in any way you like. A good practice when creating a design is to first use a pencil and a straightedge to sketch horizontal guidelines for yourself. These will help keep your writing straight. Once you have your line, you can pencil in where you want your words to go, to make sure you like the spacing and layout. Then, trace over the words with your marker to create the finished design. The last step is to go back and erase your pencil lines once the ink has dried.

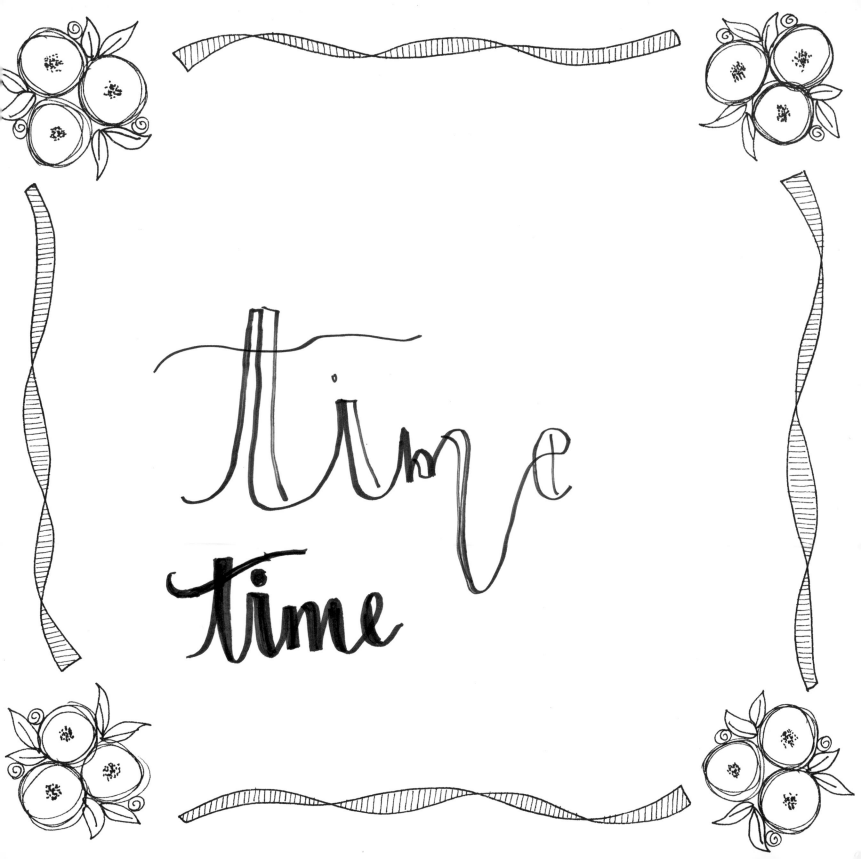

time

time

NEXT-LEVEL LAURELS, WREATHS & VINES

Certainly one of the most important components of lettering involves writing letters themselves, but there's more to it than just the alphabet. Embellishments are a key element of creating hand lettered art. Things like flourishes, frames, arrows and vines help transform a piece of text into a piece of art. In this workshop, we'll be looking at one of the most basic embellishments and learning to combine it with our faux calligraphy to take your lettering to the next level.

PRACTICE MAKES PROGRESS

All of us are familiar with the saying, "Practice makes perfect." Honestly? It's not true! None of us are perfect, no matter how hard we try. We can practice forever and still not reach that goal. But that doesn't mean it's not worthwhile to keep practicing and learning. No matter what we're doing, what we need to remember is that practice does make something: progress. Every time we do something another time, we get better at it, whether it's hand lettering, cooking or playing a musical instrument. The more you try, the better you'll become. Instead of getting frustrated that you're not able to create the letters or embellishments perfectly, focus on the process and your progress. Is what you did today a little bit better than yesterday? Give yourself permission to celebrate that! Do the same thing each day and over time, you'll look back and be amazed at how far you've come!

Ready for the next step?

LAURELS, WREATHS & VINES WORKSHOP

As a reminder not to set unreachable goals, we're going to letter this phrase, "Practice makes progress," then add a simple, lovely vine embellishment to make it even more beautiful.

First, we're going to write the phrase using the faux calligraphy technique we worked on in the last workshop (page 8). Remember, just start by writing in cursive and leaving a little extra space between letters. Then add your double line on the downstrokes and fill it in to create the brush lettering look!

Next, we'll add the embellishment. The laurel, or leafy vine, is one of the most popular ways to add a decorative touch to your lettering, and it's really easy to do. All you need to do is combine a few basic shapes, and you'll be embellishing your work in no time.

STEP 1

Draw a curving line. It can be as long, short, straight or curved as you like.

STEP 2

Draw a teardrop shape on one end of the line.

STEP 3

Draw a series of heart shapes going down the line.

You can make all the hearts a similar size, as shown above, or gradually draw them bigger as you get to the base of the line for a different effect.

Once you have the hang of creating laurels, there are so many variations you can do on this embellishment, including coloring in the leaves, making the leaves more pointed, alternating the leaves or adding berries or flowers. You can also play around with different shapes, making your vines straight, curling in multiple directions and even turning the laurels into a wreath! Simply sketch a few circles, then add your leaves.

Now it's your turn. Use the space below to practice your own laurels, then create your lettered design on the next page.

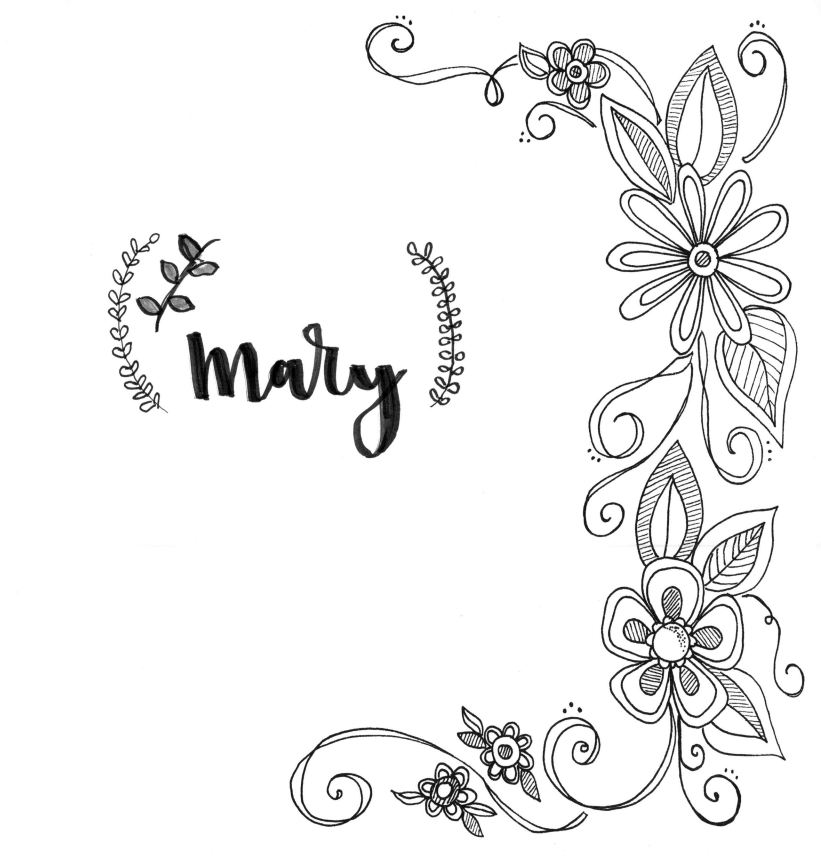

BASIC BANNERS

Whenever you letter a phrase, there will be certain words you want to emphasize. One fun way to draw attention to a word is by putting it inside a sketched banner. This not only makes the word seem to pop off the page, it also adds a festive touch to your art. It's perfect for birthday cards and other celebratory messages, as well as just about any other phrase you're illustrating. Although banners may look intimidating, they're actually a piece of cake to draw once you break them into basic steps and shapes.

LIFE BEGINS AT THE END OF YOUR COMFORT ZONE

As the rope slowly extended and my feet left the boat, everything in me wanted to scream, "No!" We were in Myrtle Beach on vacation, and somehow my husband had convinced me to parasail. I'm not a daredevil by nature, and I also never learned to swim, so the idea of flying hundreds of feet above the ocean supported only by a rope, harness and parachute terrified me. But you know what? When I finally opened my eyes, it was exhilarating and incredibly peaceful so far above everyone and everything. As I relaxed and let myself experience what was happening, I realized how much I would have missed if I'd kept my feet on the boat. Although we don't all have the opportunity to parasail on a daily basis, we do make choices every day about whether we're going to stay where we're comfortable or push ourselves to do something that might not come naturally. Are we going to play it safe and possibly miss something amazing, or are we going to step out of our comfort zones and see what happens? What challenges await you today? What might you experience if you just say yes?

Maybe setting aside time to letter and be creative is a challenge for you, and if so, now is the perfect time to step out and see what you can do. Let your self-doubt go and just enjoy the opportunity to create! So, what do you say, are you ready to tackle our next tutorial? Let's go!

BASIC BANNER WORKSHOP

This week, we'll be lettering the phrase, "Life begins at the end of your comfort zone," using those awesome faux calligraphy skills we learned in workshop one (page 8). Remember, the more you practice a technique, the more natural it becomes, so let yourself relax as you go through the motions of forming the letters. The words, "life begins," are the part of this phrase we really want to emphasize, so we're going to place them inside a decorative banner. Here's how to create it!

STEP 1

Draw a curving line. Allow as much space as you want for your word(s), then draw a second line below it with a curve that mirrors the first one.

This will be the center part of your banner. It can be as long or as short as you want it to be. The bottom line should be just slightly shorter than the one above it.

STEP 2

Connect the top and bottom of your banner with short vertical lines.

I like to make mine just slightly curved outward.

STEP 3

Draw a line about halfway up each side of your banner to create the top of the "tails."

STEP 4

Finish off your tails. To do this, draw a sideways "v" shape, then connect it to the bottom line of your banner.

Don't worry about getting the sides perfectly even or symmetrical. Remember, the point is that these are drawn by hand, not by a machine, so a little bit of irregularity is part of the charm. This is all about relaxing and doodling for fun, not perfection.

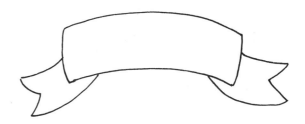

STEP 5

Make a small curving line connecting the bottom corner of your banner to the place where the tail connects to it.

This creates the appearance that the banner is folded.

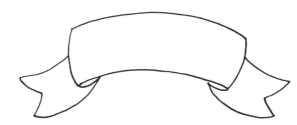

STEP 6

Add details, like coloring in the fold spaces and drawing accent lines on the top and tails.

This part is totally optional. Have fun playing around with different accents and see what you like best!

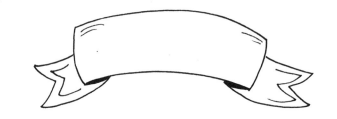

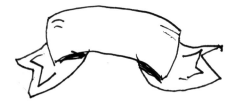

Practice forming a few banners in the space below. Then, when you're ready, hop on over to the next page and combine your banner with the lettered phrase to create this workshop's piece of art! A good first step is to sketch everything in pencil first, then go back over it with your marker. It's a good idea to letter the "life begins" phrase first, then draw the banner around it to make sure the words fit inside. Otherwise, you may find yourself running out of space with a few letters left to go. Finally, center the remaining words below the banner to complete the design. Once you're satisfied with how everything looks, it's time to trace your final copy with your brush marker or pen and erase the pencil lines for a great finished look.

Mary

mary

adventure

SAFETY

ALL ABOUT AMPERSANDS

One of the most useful embellishments to learn in your hand lettering journey is the ampersand. This symbol not only represents the word "and," but can also be a decorative design element. Depending on what you want the focus of your piece to be, the ampersand can be a central element or a small, inconspicuous one. No matter how you choose to use it, though, it always adds a touch of style.

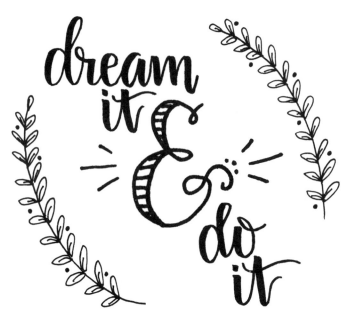

DREAM IT & DO IT

All of us have dreams. I'm not talking about the kind we have in our deepest sleep, but the kind that transcend what we're actually doing and help us imagine what *could* be. What is it that you would do if you knew you couldn't fail? Where would you go if money were not an obstacle? One of the things that successful people seem to have in common is that they persevere past whatever stands in their way in order to pursue their dreams. It's rarely easy. Just read the biography of someone you consider a success and you'll likely find many stories when he or she ran out of money or met with failure. What you'll also find, though, is resilience and an unwillingness to let those things be the end of a dream. Chasing your dreams requires persistence, especially when things seem impossible. What would it take for you to go from dreaming to doing?

Speaking of doing, it's time to get some hands-on practice working with ampersands. Let's get started.

AMPERSAND WORKSHOP

This workshop's phrase features an ampersand right in the center: "Dream it & Do it!" Since it's both our newest skill and significant to the saying, we're going to make it the focal point of the design.

There are many ways to draw this symbol, and you can embellish it as much or as little as you like to create totally different effects. Here are the basic steps you'll want to follow, but feel free to exercise a little creative freedom, too.

STEP 1

Draw a shape that resembles a backwards "3" or a cursive capital "E."

I like to add a little loop in the center, but it's totally up to you.

STEP 2

Add a loop with a curving line to the bottom.

Ideally, steps 1 and 2 will become one fluid motion, but for now as you're practicing, it's totally fine to work one step at a time.

STEP 3

Add a loop to the top.

Again, this is totally optional, I just like to add it as an extra embellishment. You can also leave the top plain, reposition the loop or use a small straight line instead.

STEP 4

Go back and add an extra line to the downstroke areas.

This is the same thing we do with our letters in faux calligraphy. You can leave your ampersand just like this with the open double-line look, or you can move on to Step 5.

STEP 5

Color in between your lines to thicken the downstrokes.

This is a basic ampersand. There are lots of stylistic choices you can make, though, to embellish and personalize it!

For example, instead of coloring in the lines, you can add stripes, polka dots or any other pattern you like!

Here are some sample ampersands with variations to inspire you as you create your own.

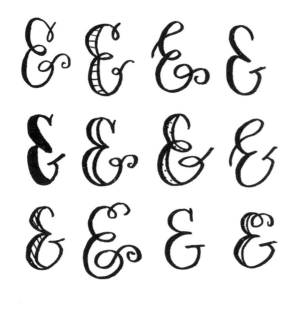

Use the space below to experiment with these styles and doodle a variety of your own ampersand symbols. Remember, lettering is all about relaxing and having fun, so don't worry about copying mine perfectly, just let yourself play! See what you like and what you don't, then choose what look you want to incorporate into this workshop's design. As you sketch your quote, you can start with the ampersand first, then position your words "dream it" and "do it" above and below the symbol. It's a good idea to work in pencil first to make sure you're happy with the spacing and overall look of your design. Remember, since you can erase it, you have permission to make as many mistakes as necessary! Then, once you have something you love, go back and make a final copy by tracing your sketch with a marker.

WHIMSICAL PRINT ALPHABET

When it comes to creating lettered designs, each different font style or type of embellishment is like a tool. The more tools you have at your fingertips, the more interesting your art will be and the more you can customize it to create something truly unique. So far, we've been focusing on faux calligraphy, which is a great option for script. Now it's time to add a new tool to the mix by practicing a print alphabet that we can mix in for a fun, playful feel.

NEW day NEW chance

NEW DAYS AND SECOND CHANCES

All of us make mistakes every single day. Some barely affect us, while we carry others with us for a long time. I remember one moment several years ago when I felt like the worst mother ever. The toilet was overflowing, flooding our upstairs bathroom, and I was perched on the lid trying to make it stop. In one hand, I held a valve that had broken off. In the other, I held a cordless phone in the hopes of calling my husband. Of course, as luck would have it, the battery was dead. In that moment of desperation, I screamed profanities I haven't repeated since and hurled the phone across the room . . . only to find my then three-year-old son watching from the doorway. I worried that I had scarred him for life, but guess what? He doesn't remember it at all. Many days have come and gone since then and each one has offered a fresh start. A new chance to be the person I want to be. The same is true for you. No matter what mistakes we made yesterday, we have an opportunity to start again and move forward every time we get out of bed. Are you making the most of those second chances? Are you allowing yourself to forgive and forget what went wrong so that you can take advantage of a new day?

Today, instead of focusing on past mistakes, let yourself relax, be in the moment and start fresh with this fun exercise.

WHIMSICAL PRINT WORKSHOP

Combining two or three different font styles adds visual interest and balance to your hand-lettered designs. Pairing print and script is always a great combination and allows you to emphasize certain words in a phrase. In this workshop, we're going to letter the phrase, "New Day, New Chance," using the faux calligraphy technique (page 8) we've been practicing along with this new Whimsical Print font.

STEP 1

Print your word.

I used all caps for this example, but you can use lowercase letters too if you like. Make sure your letters aren't too close together since you'll be adding extra thickness to some of the lines.

NEW

STEP 2

Add a double line to one side of each letter.

This is quite similar to the technique we use when creating the faux calligraphy, but instead of thickening the downstrokes, the thick line is almost always going to be on the left. There are a few exceptions; letters with stems on the right like "d, g, q, u and y" will be thickened on the right.

NEW

STEP 3

Fill in the spaces with your marker.

Typically, I do this with the same color I used to write the word.

NEW

For a totally different look, though, you could choose any color you like and use markers or even watercolors to fill in the spaces.

For your reference, here is a look at the whole alphabet, both upper and lowercase, written in the Whimsical Print style.

Aa Bb Cc Dd Ee
Ff Gg Hh Ii Jj Kk
Ll Mm Nn Oo Pp Qq
Rr Ss Tt Uu Vv Ww
Xx Yy Zz

Once you've got the hang of it, it's time to mix together the two font styles you've learned so far and letter your phrase! You'll want to start by sketching three straight horizontal lines on the page as guides for your lettering. Then write the word "NEW" on each of the first two lines in Whimsical Print. Take a look at my example at the beginning of this workshop for ideas about where to place it. Don't worry about filling in the spaces with your pencil, we're just working on positioning your words within the design. Sketch the placement for "day" and "chance" as well, this time in script. Once you're happy with the layout of your words, use a marker to go back and trace the letters, this time adding the extra strokes and filling in the spaces for a finished look. Erase any visible pencil marks and your design is complete!

SIMPLE SWIRLS

One more way to embellish any hand-lettered piece is by adding some simple swirls. These are fun and easy to doodle and can add either whimsy or elegance to your design, depending on how you use them. Learning to play around with swirls is also an important first step toward learning the fancy flourishes we often think of when we picture hand lettering. Once you get the hang of these, there's no limit to what you can do with them!

COMPARISON IS THE THIEF OF JOY

There's a game we all play every day that no one ever wins. It's called the Comparison Game. You know how it goes. You visit a friend's house and immediately focus on all the ways it's better than yours. You look at someone else's kids and either wonder why your children don't behave like them or think, "Thank goodness my kids don't act like THAT!" We all compare on a daily basis, often without even realizing it. We compare our appearance, our spouses, our kids, our homes, our cars, our careers, our talents and our "stuff." We compare our own blooper reels to others' highlight reels and feel like we don't measure up. It's time to bow out and stop playing the game. There will always be someone younger, prettier, more talented, richer and more successful than you are. There will always be someone with nicer things. But there are also a lot of people who are looking at you and wishing they had what you have. If you step out of the game and focus on appreciating what you have, your outlook on life will change dramatically. It's time to stop comparing and start learning to be content. Today, will you commit to trying not to compare?

Now let's head into this week's workshop, and remember as you create your design not to get caught up in comparing it to the example or to anyone else's work. It's all about your own progress and having fun!

SIMPLE SWIRLS WORKSHOP

To help remind yourself that no one ever wins the Comparison Game, we're going to letter the phrase "Comparison is the thief of joy" and incorporate some simple swirls.

Many beginner lettering artists are intimidated by the idea of creating swirling embellishments, but the truth is, you already know how to start. All of us can easily draw a spiral, right? A swirl is simply a spiral that's been extended. Let me show you what I mean.

STEP 1

Draw a basic spiral.

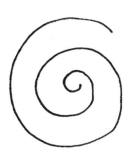

STEP 2

Begin drawing another spiral in the same way, but instead of continuing around, send your line straight out to the side.

The direction we take this line in, as well as how we manipulate it artistically with loops, curves and more, is the key to creating beautiful flourishes.

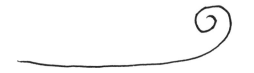

STEP 3

To form a pair of swirls, once again you'll start with a spiral motion, but you'll want to create the spirals in opposite directions.

The one on the left should be formed with a clockwise motion, while the one on the right will be counterclockwise. Let the lines come down in between the two spirals.

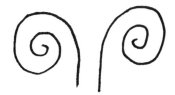

STEP 4

For a more elegant, artistic effect, repeat the same steps but allow the lines to gradually curve toward the center rather than coming straight down.

Varying things like how far apart the spirals are from one another will give them a totally different look.

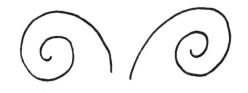

Now, let's work on creating one continuous line with swirls on both ends. Begin on the left with a clockwise spiral. As your pen gets to the top, allow it to continue out into a line that curves slightly downward. Then, take that line and go right into a new spiral, counterclockwise this time. That's all there is to it!

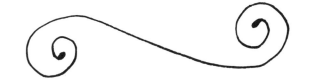

Swirls are embellishments all by themselves, but you can embellish them further by adding things like a double line, tiny teardrop shapes on the ends and just about anything else you can think of.

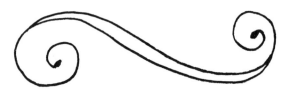

One more variation of the simple swirl is this little design that works beautifully in corners. Beginning with your clockwise spiral, let your line go upward and form a loop before coming back down and finishing with a counterclockwise spiral. This one will take some practice to get the loop centered and the sides even, but once you master it, it's a pretty little accent!

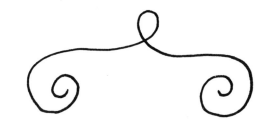

Like the others, this swirl can be enhanced with details to make it even more elegant.

The last variation of the simple swirl that we're going to explore is combining it with our lettering. Swirls work particularly well at the beginnings and ends of words, or both! All you need to do is start with a clockwise spiral, then as your line branches out to the side, use it as the beginning of forming your first letter. Continue writing, then as you finish your word, extend the line out to the right and wrap it into a spiral.

What do you think? Doesn't it add an air of elegance to even a very simple script? In today's design, we're going to be using our swirls to accent the word "joy." Let's take some time to practice the technique below. Try to keep your pen moving at all times to create nice, smooth lines. Like our other skills, it takes repetition to feel comfortable, so don't give up! Just keep practicing and you'll get the hang of it in no time.

To create our featured design, start by penciling in four horizontal lines for the text. Next, you'll want to sketch the placement of the words and embellishments. "Comparison" will be centered on the top line, and "joy" (including its swirls on both ends of the word) will be centered on the bottom line. You can refer to the example at the beginning of the workshop for the placement and font style of the other words. Finally, sketch curving vines on both sides of the word "joy" to embellish it and make it stand out as the most important word in the phrase. Once the design is to your liking, it's time to go over it with your marker. Feel free to color in the vines if you like, or do anything else to make the design your own.

AIMING FOR ARROWS

Over the past several years, arrows have become a very popular design element in advertising, fashion and home décor. They fit perfectly with a tribal or boho theme and are great to use in hand-lettered projects of all kinds. Arrows are quick and fun to doodle and there are endless variations you can create once you learn the basics.

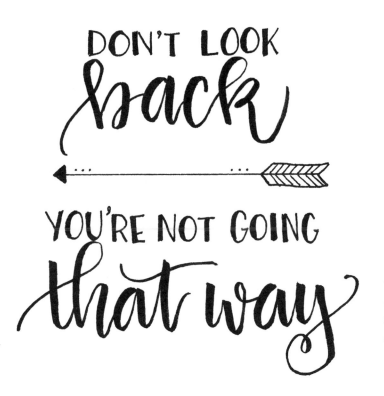

DON'T LOOK BACK, YOU'RE NOT GOING THAT WAY

There are certainly times when looking back to the past is beneficial and even necessary, but getting stuck there can keep us from moving onward to great things! Recently we talked about how each day is a new start, so it's time to give ourselves permission to forget about our failures. If we've done our best to learn from them or seek forgiveness and make things right, it's time to move on. If we continually beat ourselves up over the times we haven't succeeded, how can we put all our energy into reaching our goals today? It's time to put those things behind us and leave them in the past so we can focus on what's ahead. Yesterday's failures are simply stepping-stones to tomorrow's successes. Once, when Thomas Edison was asked about all his unsuccessful attempts to create the lightbulb, his response was, "I have not failed. I've just found 10,000 ways that won't work." Why not take that awesome attitude into our own lives and use our mistakes as tools to help us as we continue to strive for what we want?

To help point us in the right direction, let's play around with some arrows! As you work on this new skill, remember to see your mistakes as opportunities to grow and improve as an artist.

ARROW WORKSHOP

The arrow in our design this week is more than just an embellishment to make things pretty, it visually reinforces the message of the phrase, "Don't look back, you're not going that way." We'll be combining it with our faux calligraphy technique (page 8) and Whimsical Print font (page 24) to write our quote.

STEP 1

Draw a horizontal line.

If you're one of those folks who needs it to be perfectly straight, by all means use a ruler or other straightedge. Personally, I like the imperfection and hand-drawn vibe that a slightly crooked line gives. It's all about personal preference.

STEP 2

Draw a triangle arrowhead.

I colored mine in with a black marker, but you could also leave it open or fill it in with a colored marker instead.

STEP 3

Draw an inverted "V" at the end of your arrow.

Again, don't worry about perfection. The point is that it's hand lettering/doodling, not a computer-generated graphic, right?

STEP 4

Draw another inverted "V" about ⅓ of the way up your arrow stem.

If you want the tail of your arrow to be shorter, place the second "V" closer to the first one. Want it longer? Make it closer to the arrowhead. Wherever you draw it, just try to make the angle of the "V" a close match to your original one.

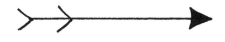

STEP 5

Connect your "V"s with horizontal lines.

You can freehand this or use your straightedge; either way, you're forming the tail of the arrow.

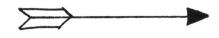

STEP 6

Draw several more "V"s inside the arrow's tail to add detail.

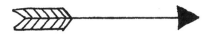

STEP 7

If you like, add some dots along the horizontal line just to make things a little fancy!

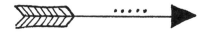

That's all there is to it! You can do all kinds of simple variations on this arrow design too. You can color it in using whatever markers you like or make your arrow curved instead of straight.

In the space below, play around with these basic elements to create your own arrows. Then move on to using one in this week's featured design!

Speaking of our design, a good place to start is by sketching five horizontal lines to help with spacing and placement. I like to start at the top of a design like this and work my way down, so pencil in the phrase starting with the words "don't look" in Whimsical Print (page 24) on the first line. "Back" should be centered on the second line in script, and then it's time to create your arrow below it on the third line. Finish penciling in your words on the lower lines, then trace your design with a marker to make it complete.

PLAYING WITH SERIFS

Have you ever noticed that the names of certain fonts contain the word "serif"? A serif is a small line attached to the end of a stroke in a letter or symbol. Serif-style fonts make use of these little decorative lines, while sans serif ("without serif") fonts do not. Serifs first appeared in the Latin alphabet when words were inscribed into stone. The reason is unclear, although some folks think it was to neaten the appearance on the ends of the chiseled letters. Today, serif fonts are often used in typography because they are considered easy to read in print and on computer screens. So, what does this mean for us as artists? Serifs are yet another tool we can use to embellish our lettering. They can give a print font a totally different look, and the serifs themselves can be formed in a variety of ways for decorative purposes.

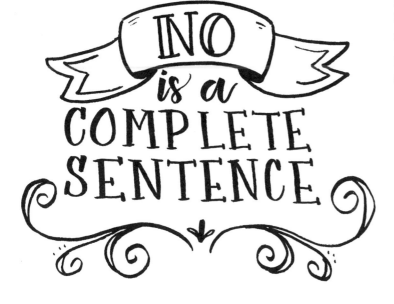

SAYING NO

If you've ever had a toddler, you know that the universal favorite word of small children is "NO!" Why is it that we love that word so much when we're small, but as we get older, it becomes harder and harder for many of us to say? Ever since I can remember, I've hated to disappoint people, so I find it really difficult to turn down someone's request even if it's not in my own best interest. I've ended up working extra hours, taking on responsibilities, accepting projects and doing all kinds of things that I didn't really have time for just because I couldn't bring myself to say no. But in the end, that's destructive for me as well as for my family. My encouragement for all of us (because I'm still learning too!) is to remember that "no" is not a bad word. It's a healthy word for us to use to help maintain a balance in our lives. Even if it means disappointing someone else, just say no when it's the answer you need to give.

Now let's create a little reminder for ourselves that "NO" is sometimes the right response!

SERIF WORKSHOP

In this workshop, we're going to letter the phrase "No is a complete sentence" while adding serifs. We're also going to make use of your banner and swirl skills (pages 16 and 28) to take the design to the next level.

Adding serifs to a font is actually quite simple to do. If you can draw a line, you can create a serif. Let's take a look at the letter "A" as an example. First, go ahead and print a capital "A" normally. Then add a short horizontal line to the bottom of each side of the letter. That's all there is to it! If you want a fancier look that's even more decorative, you can form a tiny triangle shape instead.

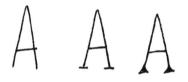

Serifs can be added to just about any style of print font. Try adding them to your regular print handwriting first, then play around with putting them on the Whimsical Print alphabet (page 24). They're just for decoration, so you can decide in any given piece whether they're the right fit or not. The process of creating the actual serifs is incredibly simple, as you can see; the hard part is figuring out exactly where they go. To the right is a sample serif alphabet to use as a reference for placing your short lines. Take some time to practice writing each letter several times and get a feel for where the serifs belong.

ABCDEFGHIJKL
MNOPQRSTUVW
XYZ

abcdefghijklmno
pqrstuvwxyz

Once you're feeling somewhat comfortable with adding your serifs, it's time to move on to our lettered design. First, draw yourself a basic banner and add the word "NO" inside using the Whimsical Print style. I chose to leave mine open rather than coloring in the double line area, but you can personalize yours any way you like. Add serifs to the appropriate spots of the "N." Then, write the next part of the phrase just below the banner in faux calligraphy. Finish the phrase in printed capital letters, adding serifs to the letters where they belong, using the sample alphabet as a reference. Your last step will be adding some simple swirls to embellish. I started by making the two largest swirls first, then branching smaller ones off of them. Feel free to color in your design to make a bright, pretty reminder for yourself that saying no is sometimes a decision you need to make.

CREATING COLORFUL FLOWERS

The first embellishment we learned to help decorate our lettering was a curving vine. There are lots of other natural elements that pair wonderfully with lettered designs too, including flowers and leaves. These particular kinds of illustrations lend themselves perfectly to being colored with markers or colored pencils, which serves the dual purpose of adding vibrant color to our designs and giving us the opportunity to relax and enjoy filling them in. There are as many ways to draw flowers as there are varieties of flowers in nature, so there's no wrong way to do it. Today, we are going to look at one particular technique that's incredibly easy to do and is based on very simple shapes and lines.

YOU ARE ENOUGH

On any given day, I am a mother, a wife, a daughter, a friend, an employer, a neighbor, a blogger and an artist. With each of those roles comes a unique set of responsibilities. Honestly, most days it feels like there's not enough of me to go around. There are only so many hours, which means not everything gets done. As I look at what I didn't accomplish, I feel like I failed . . . and I don't think I'm the only one caught in this cycle. All of us play many roles and are responsible for more than we can actually do. Even though we know it's impossible to stay on top of it all, we hold ourselves to that standard anyway. Can I just say something to you right now, friend? No matter how many things you crossed off of your to-do list today, you are enough. Yes, you. The people in your life don't value you for how much you accomplish, they value you for being yourself. Your kids, your spouse, your parents, your friends and neighbors love you for who you are. They treasure your kindness. They appreciate your advice. They enjoy spending time with you. You are enough. You'll never finish all the things, and that's 100 percent okay. None of us ever will. So let's not use that as a way to evaluate ourselves. Instead, remember that no matter what you did or didn't do today, you are enough, just by being you.

Ready to create a reminder of this for yourself? Let's get started!

FLOWER WORKSHOP

One of the prettiest ways to embellish a quote is with flowers, so we're going to learn how easy they are to create in a few simple steps.

STEP 1

Draw a circle.

Don't worry about it being perfect. If you want, you can do this in pencil first, then go back over it with a marker later.

STEP 2

Draw several more circles that are close to and overlapping your original one.

Once again, don't worry about perfection . . . really! Just relax your hand and let yourself sketch.

STEP 3

Draw the center of the flower by placing a bunch of dots together with several that are a little more spread out.

That's all there is to the basic flower, other than coloring it! You can make these in a variety of sizes and draw them individually or in groups. I often like to place mine in groups of three because it provides good visual balance.

STEP 4

Color your flowers.

Now comes the fun part! I like to play around with dual-colored brush markers and blend colors together, like different shades of pink, orange and yellow. Of course, you can use any colors and supplies you have on hand, including watercolors and colored pencils. In fact, you can even borrow your kids' crayons if that's what's available.

STEP 5

Add branches/stems.

Draw a long curving line with a few shorter lines coming off of it. I like to add small circles at the end of each line, which can be berries or buds.

STEP 6

Draw and color leaves.

For this step, create a basic leaf shape, then draw lines in the center for the leaf veins. Once again, I like to play around with mixing different shades of color to add interest.

See, friend? It's easier than it looks! Combining a few lines and shapes with some pretty colors will have your page full of flowers in no time! Play around with creating your own floral embellishments in the practice space below, then combine them with your faux calligraphy to create the important reminder that you are enough, just as you are.

This design keeps things simple so you can focus on the message and the pretty flowers. Simply write the words of the quote in faux calligraphy and add a group of flowers and vines to the left of it. I used two lines for my message, but you can position yours however you like to create your own unique masterpiece.

PRETTY PENNANTS & ADVANCED BANNERS

Congratulations, friend! You are now ten workshops into this journey, and you have a variety of skills under your belt. You've learned a script font, a print font and several embellishments to decorate and add color to your work. Now that you've mastered some basics, it's time to build on some of what you've learned and advance it to the next level. Remember the banner we learned back in workshop three (page 16)? I hope you've been finding it useful so far to emphasize certain words and add a celebratory feel to lettered phrases. Today, we're going to look at several variations that will allow you more creative freedom as you work banners into your designs. We'll learn how to curl them in opposite directions, turn them into flags and more, giving you lots of options!

FIND THE GOOD IN EVERY DAY

Have you ever had one of those days where everything goes wrong? Last Tuesday, I did. After a million little frustrations, the last straw came when I was making dinner. We were having tacos, and at the last minute I realized I had no seasoning. At the same time I discovered that the rice had stuck to the bottom of its pan and was burning, filling the kitchen with an awful smell. I wanted to cry, throw things and resign as a grown-up. I felt sorry for myself, and for my husband who came home to a grumpy wife. But it was actually my hubby who turned things around. He had my favorite pizza delivered and bought me a giant cupcake. Then he listened sympathetically while I vented about everything, all the way up through the ruined meal. As I expressed my frustration, he grinned and said, "but you got pizza out of it!" I couldn't help but laugh. He helped me look past all the things that didn't go my way and focus on the good. And trust me, the pizza and cupcake were very, very good. None of the bad things about my day changed, but my attitude did. Once I shifted my perspective, I was able to enjoy the rest of my evening and even found more good things to celebrate. Next time you find yourself focusing on the negative, stop and look for the silver lining. I promise there's one somewhere.

Hopefully, creating art is one thing that puts a smile on your face, so let's get started with this workshop.

PENNANT AND BANNER WORKSHOP

In today's design, we'll be lettering a reminder to look for the good in our lives while incorporating a new advanced banner. Previously, you've been working with this basic banner, which is a great beginner tool.

However, not every design lends itself to an embellishment of this particular shape and size. Once you've mastered the elements of creating a banner, you can manipulate them to create something that's any size and style you like. You can curl it into different shapes, turn it into a pennant and more, just by altering a few of the lines. Let's start by taking our basic banner and twisting it in a different direction.

STEP 1

Draw two lines with the same basic curving shape. Move your pen up, then down, then back up again.

Just as you did in the simple banner, make sure the lines stay a consistent width apart.

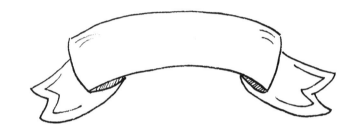

STEP 2

Connect the two curving horizontal lines with vertical ones on each end.

Again, this should feel familiar. The only thing we've done is changed the shape of the curving lines.

STEP 3

Draw small semicircles to connect the vertical lines to the banner itself, but this time the one on the left should connect to the bottom of the banner, while the one on the right connects to the top.

This will give the banner the illusion of folding back on itself.

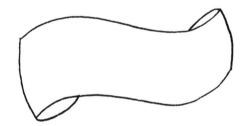

STEP 4

Draw your banner tails.

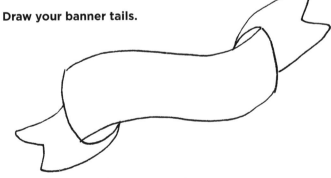

STEP 5

Add embellishments by shading in the folded areas and drawing short accent lines.

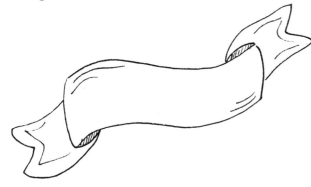

Easy-peasy, right? Now we're going to take this curving banner to yet another level by extending it. Start with steps 1–3. When it's time to draw the banner tails, stop before adding the "v" shape that finishes them off.

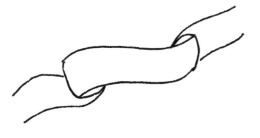

Now, repeat steps 2–4 of the process. Draw your vertical lines, your semicircles and tails.

Add any embellishments you like, then your banner is ready to hold words.

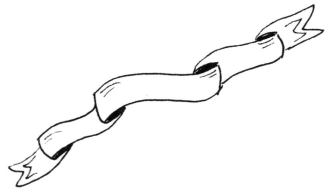

This process can be done for banners of any shape, like this one below, which nicely frames the bottom of a design. This is what we'll be using in today's quote. Simply sketch the initial banner, leaving the tails unfinished, then continue with them as though they were the original banner.

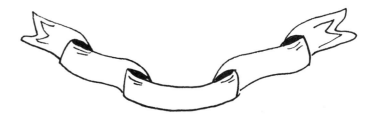

These banners look awfully impressive, but are really just slight variations from the one you've already mastered. Creating a pennant or flag is similar, too. A pennant is basically a one-ended banner. Form your curving lines and connect them with vertical lines, but as you continue, only do steps 3–5 on one side, leaving the other empty.

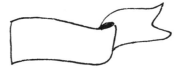

Then you're ready to sketch a flagpole, stick, or whatever else you like on that blank side.

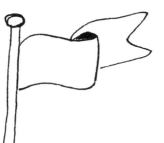

Depending on the look you're going for, you can play around with the shape of the pennant's end, giving it a point or making it flat in place of the inverted "v".

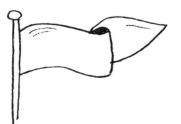

For extra flair, you can use the advanced banner technique to give it multiple folds. Remember, it's the exact same process, just on one side instead of both.

Take some time to play around with these variations on your basic banner to see what you like best! When you're ready, go ahead and create this week's design! It's just a combination of faux calligraphy (page 8) and Whimsical Print font (page 24) with the advanced banner so you can see how useful this is in adding flair to a phrase. I like to sketch my banner in pencil first to make sure I'm pleased with the overall symmetry and positioning. Then, I pencil in my words to make sure they fit. When all of that is complete, I add the other words above the banner and finalize everything with a marker.

BIG & BOLD 3D FONT

Sometimes a design just calls for color! Today we're going to look at a fun new font style that features letters in your favorite colors along with a three-dimensional effect. It's easier than you think to create letters that seem to pop right off the page. So grab your colored markers, along with thin gray and black ones, and let's get started.

INSPIRATION IS EVERYWHERE

Whether or not you consider yourself an artist, there's something I know about you, friend. There are things in your life that inspire you. Maybe you are inspired visually, like I am. I see something awesome on Pinterest or in a store and think to myself, "I want to make something like that!" Perhaps you're inspired by raw materials; you look at a piece of wood or a ball of yarn and can imagine the possibilities of a finished project. Maybe you are inspired by nature, by music, by beauty. All of us find inspiration in different places, but one thing is for sure, we all need it. Inspiration is what drives us to create! It's what makes us dream and change and grow and take risks. What inspires you? Today, spend some time enjoying it!

Speaking of inspiration, I hope you're inspired to create all kinds of beautiful things when you see this colorful new lettering style . . . take a look!

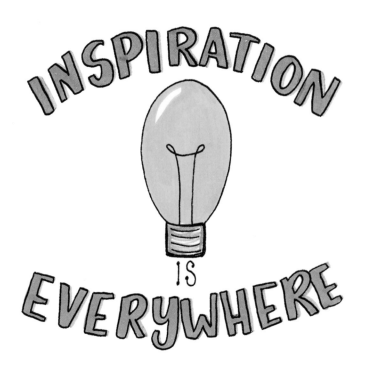

3D FONT WORKSHOP

Our featured design this week is a fun one; we'll be using our 3D Font to letter around a lightbulb!

Before we create it, though, let's take some time to learn how our font works.

STEP 1

Write your letters in colored marker.

There are sample alphabets at the end of this exercise that show how I form my letters, but any way you write, this still works!

STEP 2

Trace around the outside edges of each letter using a thin black marker.

STEP 3

Add gray shadow lines.

One reason I like using Tombow Dual Brush Pens for this is that one swipe of the brush tip makes the perfect width shadow. I like to place my lines as though a light were shining from the left, placing shadows to the right.

I've included sample alphabets for you to use as references for where to place the shadows and how I draw my letters. Feel free to play around with the style and make it totally your own, though!

Once you've gotten the hang of it, the real fun begins as you put the letters together to make words. I personally enjoy mixing and matching uppercase and lowercase letters to create a whimsical look. Often, I use capital letters for consonants except for "m" and "n" and lowercase for vowels. Other times, though, I just mix things up randomly. Play around with the letters and see what works with your personal style!

abcdef
ghijkl
mnopq
rstuvw
xyz 012
3456789

mix & match

When you're ready to create your finished design, you'll want to start with the central point, the lightbulb. It's simply a rounded shape with a curved rectangle on the bottom. Begin by sketching it in pencil, then write your words around it in a gently curving shape. Finally, use your colored markers to turn your sketch into a bold, beautiful design.

THE ART OF BLENDING COLORS

One of the most fun parts of creating lettered designs is adding color! Whether it just pops here and there or is a whole watercolor background, color brings dimension and excitement to a piece of art. Colored pencils, markers of all kinds and even crayons are useful tools, but for today's technique, we're going to be talking specifically about Tombow Dual Brush Pens. These pens are water-based and specially created to be able to blend with one another, creating beautiful watercolor effects. With several of these markers in hand, you can create a brand-new color, an ombre effect, shadows or fading.

BEAUTY-FULL

Our society places a huge emphasis on beauty, and as a result it's something almost every woman I know struggles with, myself included. We all want to feel beautiful, while at the same time we see all of our own flaws. I once had a discussion with some close friends about how none of us have an accurate perception of our own weight and appearance. When I look at my friends, I see an attractive group of women with gorgeous smiles as well as inner beauty that shines through in all that they do. Their loving, generous hearts radiate onto their faces, making them even more lovely. But when I talk to them, each one has a laundry list of things they dislike about themselves. I do too. From my own perspective, my legs are too short, my thighs are too thick and I don't know if the "mommy pooch" will ever go away. It's easy for us to focus on those areas we'd like to change and the things we don't think are beautiful, but that's not at all an accurate reflection of who we are. Today, I want you (yes YOU!) to know that you are beauty-full. Your physical appearance AND your heart are full of beauty, regardless of what you see when you look in the mirror. Honestly.

Now, let's shift focus from the beauty you already possess to the beauty you can create! Ready to learn all about color-blending?

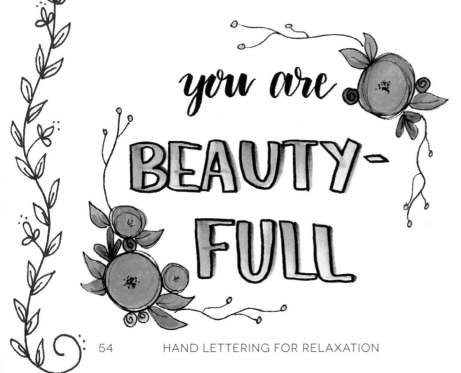

BLENDING WORKSHOP

In this workshop, we'll be using a color-blending technique along with our colorful flowers (page 40) to letter a reminder that you are indeed beauty-full!

Blending with Tombow Dual Brush Pens couldn't be easier, because it's one of the things they are specifically designed to do. There are three ways you can successfully create a blended effect; all of them work equally well, it just depends on your personal preference.

USING A PALETTE

This method works best if you want a real mix of two colors. Tombow sells a small palette made just for this purpose, but if you don't have one on hand, you can create your own by laminating a piece of card stock. The slippery surface of the palette does not absorb the ink of the pens, so when you run your pen over it, you'll get small pools of ink you can work with as if they were paints. To mix two colors together, make a few scribbles with both of them on the palette, then run your clear blender pen over them to pick up the colored ink. You can now letter directly onto your paper using the blending pen itself. It will run out of color as it uses the ink it picked up, so you'll have to reload when that happens. The example below shows how I used a blender pen to mix a bright teal and a bright green to create a new shade of blue-green.

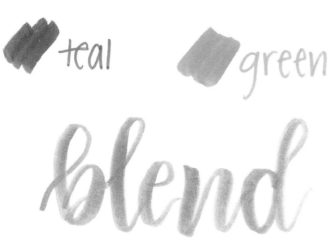

Don't worry about ruining your markers by practicing this technique! The Dual Brush Pens as well as the blender pen are self-cleaning and will go back to normal as soon as any ink they've picked up has been used.

USING THE BLENDER PEN

In addition to using the blender pen on a palette, you can also use it to help blend two colors that have already been put to paper. **This method is best when you want a greater contrast between colors.** For instance, try writing a letter in one color, then use a darker color to fill in about a third of it.

Take your clear blender pen and apply it where the two colors meet, spreading the darker color into the lighter areas. This will help make the transition from one color to the other look more natural while still maintaining the look of the two individual colors.

BLENDING DIRECTLY ON THE PEN

If you don't have a palette or blender pen, or don't feel like taking the time to find them (like me!) you can blend colors simply by coloring with one marker directly onto the brush tip of another. **This method is best when you want a gradual blend moving from one color to another as your word continues.** You'll always want to place a darker color on top of a lighter one. I typically make about seven to ten strokes of the darker color onto the tip of the lighter marker, then letter as normal. You'll see mostly the darker color at first, then it will begin to fade away into a mixture, then finally the original color. Here are three examples of the ombre-type shading this creates. The first is dark purple colored onto a light pink tip. Next is bright pink colored on the same light pink tip. The third example is orange colored onto a yellow tip.

Any and all of these techniques are easy to do and will create lovely results. Try out the various methods to see the different effects for yourself. Then choose your favorite for creating the featured design! First letter "you are" in faux calligraphy (page 8), then use whichever blending technique you like best to write "Beauty-full." I used the third method, coloring with dark purple directly onto a light blue marker. Once your letters are written, trace and highlight them just like you did in the previous workshop to create a 3D font (page 50). Finally, add groups of flowers (page 40) in two of the corners and use the blending skills as you fill them in with color.

MIXING FONTS LIKE A PRO

Mixing fonts within a design can be as tricky as it is useful. Different font styles and sizes can add balance and emphasis to your lettering, but there are also some guidelines to keep in mind. Combining fonts that are too similar in style can confuse your design, and mixing too many fonts into one piece of art can create a busy, overwhelming appearance. It's all about finding the right combinations and making sure that your overall design looks cohesive. Your fonts need to work together to create a balanced whole rather than competing or blending together. Today we'll look at a few basic combinations that will have you mixing fonts like a pro in no time.

DO WHAT YOU LOVE, LOVE WHAT YOU DO

Years ago, when my paycheck came from a very different job, I used to get what my husband called the "Sunday afternoon blues." I was at the point where I disliked my job so much that just the thought of having to get up early and go to work Monday morning crept into my mind and started to ruin the rest of the remaining day. It's a stark contrast to my life now, where I sometimes even forget what day it is because I'm so busy creating and sharing with my online community. What I do brings me such joy, and while there are always aspects to any job that aren't perfect, I get to spend the majority of my time doing what I love. The paycheck itself is smaller and our family has made sacrifices along the way, but it's hard to put a price on enjoying your life. Are you in a position where you are able to make changes in your life that would allow you to do what you love and love what you do? If so, by all means, go for it! You won't be sorry! If not, is there any way to make doing what you love a reality without completely switching careers? Perhaps your financial situation doesn't allow you to quit one thing and pursue another right now, but is there a way to do it on the side? What changes can you make to ensure that you're spending your time in ways that fulfill you and bring joy to your soul?

Hopefully you're finding that developing this hobby and giving yourself a creative outlet is a fulfilling and relaxing part of your week! Let's dive in to this workshop and learn to mix things up a bit.

MIXING FONTS WORKSHOP

In today's workshop, we'll be lettering the phrase "Do what you love, love what you do," in a combination of three fonts: faux calligraphy (page 8), Whimsical Print (page 24) and a simple uppercase print. Remember the swirls you've been practicing (page 28)? We're adding those into the mix, too!

Before we start on the design, let's talk about a few of the basic things you'll want to consider when combining fonts. You may want to highlight these four simple rules so that you can easily refer to them later.

RULE 1

Two and three are the magic numbers.
Combining more than three styles can be overwhelming to the eye.

RULE 2

Choose fonts that are both complementary and contrasting.
This sounds like a contradiction, but it actually works. You don't want fonts that are so different they don't "gel" together in a design, but you also don't want them to be so similar that viewers can hardly recognize the difference. Look for fonts with similar characteristics but varying styles. For example, a good combination is to use a sans serif font with a serif font from the same family.

SANS SERIF
and serif

Another combination you can count on is pairing a pretty script with a simple print. Too many script fonts together can be hard to read, while all print may not add enough variety.

script & PRINT

RULE 3

Consider the "mood" of your piece and choose your fonts accordingly.

If you are designing something formal or serious, think about combining a pretty brush script/faux calligraphy and a serif print. Script fonts are always elegant, and serif lettering tends to be more formal, while sans serif is viewed as casual. Capital letters also give a nod to tradition, while writing in all lowercase is definitely a more modern trend.

elegant AND FORMAL

On the other hand, if you want a lighthearted vibe, think about the total opposite! Lowercase letters, sans serif fonts and anything that has quirky embellishments will do the trick. Color adds a playful note too, while black and white is more traditional.

Whimsical & playful

RULE 4

Use fonts with a mixture of height and weights.

If all of your choices are about the same size, none of them will stand out or add any visual weight to your design. Instead, choose a thicker, darker font for things you want to emphasize, while writing the rest of the phrase in something lighter and/or smaller. The viewer's eye will be drawn to the "heavy" parts of the image and focus on those.

As you practice today's design, notice the mix of print and script as well as the visual weight of the design. The most important words are heavier in the sense that they are darker and larger than the connecting words of the phrase.

There are endless possibilities for mixing fonts. Just keep practicing with different combinations and you'll find what works best with your own style. However you do it, learning to master this skill will take your designs to the next level of creating cohesive, visually interesting art.

TALL & THIN
and compact

FUNKY FRAMES & CUTE CORNERS

When we have a photo or a piece of art we really love, what do we do? Often we put it inside of a frame. We call attention to it by placing it inside of something that draws the eye in to the image itself. We can do the same thing with our lettering using nothing more than our markers. Doodling frames, borders and decorative corner designs around our lettered pieces can be a fun way to draw someone's attention to the words inside. In this workshop, we'll look at how to create hand-drawn frames in a variety of styles to complement our favorite phrases.

BETTER TOGETHER

What's the point of setting goals if you're going to give up on them the first time things get hard? One of the best ways I've found to keep myself on track is to choose a person or two to hold me accountable for specific things I said I would do. For me, those people are usually my hubby, my best friend Erin or my mom. When I share with them what I've resolved to do, all of a sudden it's a lot harder to drop the ball because they're going to ask me about it. If I tell my husband my goal is to have a better work/family balance by not working after 8:00 p.m., suddenly he can call me out on it if I do. If I tell Erin I've resolved not to gossip, she can speak up when I'm telling her something that isn't complimentary about another friend. Inviting others to be a part of your personal goals can help you persevere and stick to what you promise. If you happen to have the same goal as someone else, you can even work on it together, like meeting at the gym or sharing healthy recipes. Today, I encourage you to choose one or two people you trust and ask them to help you stick with the goals you set. You'll be amazed by how much it helps to have someone walking alongside you and encouraging you to make them realities.

As we letter a reminder about the importance of our friends, let's take a look at how to frame it!

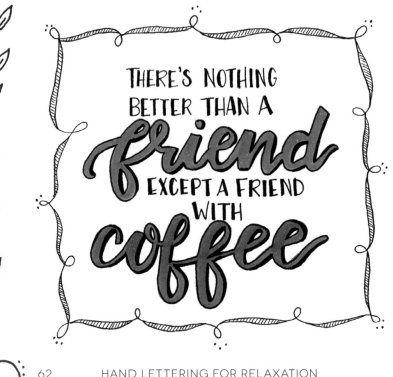

THERE'S NOTHING BETTER THAN A *friend* EXCEPT A FRIEND WITH *coffee*

FRAMES & CORNERS WORKSHOP

Today we're going to use a favorite quote of mine: "There's nothing better than a friend, except a friend with coffee!" Such an important statement is surely deserving of a frame, so we're going to put it inside one while practicing the Whimsical Print alphabet (page 24) and 3D Bold font (page 50).

There are about a million types of frames you can create using various combinations of lines, shapes, loops and more. In fact, you really can't go wrong. To get you started, though, I want to share a few of my favorites in the hope that they'll inspire you for your own projects.

#1: FUNKY FRAME

This one is the most complex, so I'm going to break it down in a few basic steps. First, practice drawing a line with loops going in opposite directions. Loop up, then down, up, then down again and so on. Try to keep your loops pretty evenly spaced.

Then, starting in the top left corner, make a line with five loops. You'll start and end with upward loops and have two downward ones in between. When you reach the corner, continue the pattern around the other three sides to form a square or rectangle shape. Reconnect your lines when you get back to the beginning.

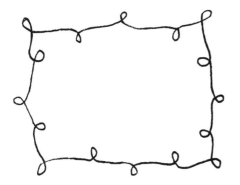

You can leave it just like this, or enhance it by adding double lines.

Once again, you can stop here, or you can continue to embellish. I like to add tiny diagonal lines in all the double-line spaces. You could also color these in with black or any colored marker you like. Finally, I add three dots around the top of each loop. That's all there is to it!

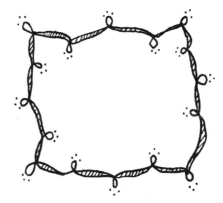

#2: HEARTS & LINES FRAME

To create this frame, the first thing you have to do is sketch four sets of parallel lines. You'll notice that none of the lines in these frames are perfect or totally straight, because I sketched them by hand without a straightedge. I prefer doing things this way because I feel like it adds to the hand-drawn effect. Of course, you can always use a ruler and/or work on lined paper if you like. The lines won't actually connect, you want to leave a little open space in each corner. Then go back and sketch four cute little hearts. You could easily substitute any other shape too, including stars, moons, circles or flowers.

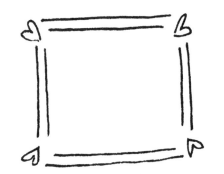

#3: SIMPLE SQUIGGLES FRAME

This is one of the easiest types of frames to create, because all you have to do is start drawing a line and add three cursive e's about ⅔ of the way across. Turn your paper and repeat three more times until you're back where you started. You can definitely add more or less e's for a variation.

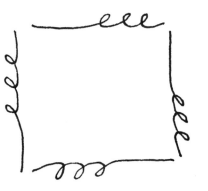

#4: POLKA DOT MARQUEE FRAME

If you have ever wanted to see your name on a marquee, all you have to do is sketch it inside this fun frame. Draw a box around your design, then add a second rectangle on the outside. Fill in the space between the lines with polka dots. Color them in with black, or leave them open and make them look like lights with a yellow marker!

#5: SHAPES & LINES FRAME

Once again, this frame is super simple to create. Just sketch your basic four lines, then draw tiny shapes across each line in alternating directions. Fill them in with your black marker or with any other color.

#6: LOTS OF LACE FRAME

Rather than straight lines, this frame is made up of curves. Create a bumpy pattern, and remember, don't worry about keeping them even or uniform. Then, draw a small circle under each bump.

#7: CROSSING ARROWS FRAME

This gives you a chance to practice your arrows (page 33) again, this time using them to create a border around your lettering. Start by drawing two intersecting lines on the top, sides and bottom of your design. Then, add your details to turn the lines into arrows.

These are just a few of the ways you can combine lines and shapes to border your lettering! Which ones are your favorites? Feel free to experiment with variations and even create your own original ideas.

Sometimes a design looks better with just a few corner embellishments rather than a full frame. In that case, one option is to adapt a frame like the Hearts and Lines, using just what you'd need for a corner.

The simple swirl variation we learned a while back (page 28) is another excellent choice for corners. You can make it as simple or as detailed as you like.

Use the space below to practice doodling the various frames and corners. Then, when you're ready, move on over to the next page and create your finished design!

As for today's design, we're going to focus on that first "funky frame" with the alternating loops. The first thing you'll want to do is use a pencil to sketch a few horizontal lines that will help keep your letters straight. We want to emphasize the words "friend" and "coffee," so we're going to give them a little extra weight by making them both colored and a bolder script by using colored brush markers. Start by drawing your pencil guidelines and sketching the positioning of your words. Write "friend" and "coffee" in two of your favorite colors, then go back and trace them with a fine-tip black marker. Add shadows, just like we did in the 3D print workshop (page 50). Then fill in the rest of the quote using Whimsical Print (page 24). Once your quote is in place, it's time to add your frame! Feel free to switch out the frame for another of the styles we learned if you prefer.

FUN WITH FLOURISHES

Fancy flourishes are one of the first things people think of when they hear the words "hand lettering." Mastering the alphabet is obviously a huge step in your lettering journey, but learning to embellish with flourishes will really begin to take your work to the next level. Flourishes can stand alone, appear at the beginning or end of a letter, or even connect letters together within your phrase. In this workshop, we'll look at some basic tips for creating beautiful flourishes that enhance your design.

TODAY IS A GIFT

It's no secret, friend, that we live in an unsettled world. Sometimes I feel as though every time I turn on the television or open my Facebook newsfeed, there's a report of some new tragedy. There are far too many stories of senseless violence and innocent victims who were in the wrong place at the wrong time. Each of those events is a reminder that we never know for sure what tomorrow holds. We can hope and plan, but life can change in an instant in ways that we never expected. That's why it's important to treat every day as a gift. Every moment we have with our loved ones is a moment we should enjoy and treasure. Each time we see a sunrise or ease into the morning with a good cup of coffee, it is an opportunity to be grateful for another day. How would it change the way we live if we decided to be fully present and to view our lives as a gift? Would we rush less? Would we laugh more? Would we make it a priority to do the things we love most? Think about it. How will you make today count?

As you ponder those questions, we're going to letter a reminder of how precious each day really is. Let's get started.

FLOURISH WORKSHOP

We're going to package today's phrase like the gift it is. After you've lettered the message "today is a gift" in a combination of faux calligraphy (page 8) and Whimsical Print (page 24), the fun really starts. But first, let's work on your flourishing skills, shall we?

Many flourishes are built from the simple swirls you already know how to create, then enhanced with extra loops. We're going to start with this type and build on your existing skills.

CURVING LINE FLOURISHES

Let's begin with this flourish, created with a downward loop and upward swirl. Place your pen on the paper and move it down, around and back up to create a loop. Continue moving the pen up and to the right, finishing with a little counterclockwise swirl. Depending on how large or small you make the loop, your flourish will have a totally different look. There's no wrong way to do it, so just relax your hand and see what happens!

Practice the motion of this flourish over and over because the more you do it, the steadier your hand will become. At first, your flourish may look shaky because you're thinking hard about how to form it and moving your pen more slowly than you will when it becomes comfortable. Don't worry. As it gets into your muscle memory, it will become a piece of cake. You'll also want to practice making your loops and swirls bigger and smaller to create different effects. You never know what style might fit best with a certain design.

Also practice creating the same flourish in the opposite direction! Often flourishes are used to provide symmetry in a design, so you want to make sure you can produce two similar flourishes that are going different ways. Here is an elegant way to put two flourishes together to create one larger embellishment. This is the same style you've just been practicing, it's just two joined together in the center at the loop.

To create a variation on this style, try it upside down! Instead of moving your pen down and to the right to start, try moving it up and to the left. Form your loop, then cross back over your original line as you get ready to finish off with a swirl.

All of these variations create the same basic style of flourish: long and loopy. They're great for using above or below a phrase or even to create a border. I want to show you one other style today that's more compact and good as a space filler.

LAYERED SHAPES FLOURISH

To create this type of embellishment, you'll need to master two shapes. The first is created by making four connected loops in a square shape. I start by creating the top loop, then go around clockwise to form the rest. It may take a few attempts before you get the hang of this, and that's perfectly fine. Just keep repeating that motion and you'll start to get a feel for it.

The other shape you're going to need is that of an infinity sign or a sideways "8."

On their own, they're not very impressive, but when you combine these two shapes, you get a pretty little decoration. First, let's try drawing the loops first, then creating an infinity shape over the top that is larger than the shape beneath it.

We can also do the same layering process but make the infinity shape smaller than the one beneath it. Make sure it doesn't extend out past the loops of your first shape. Look how that creates a design with a totally different feel!

Finally, you can add flourishes onto your written letters themselves. This is one of my favorite types of flourish to create.

LETTER FLOURISHES

First of all, here is a little embellishment you can add to the end of just about any letter you've written. To create it, once you're finished your letter, keep your pen on the paper and simply loop up, over and down across the existing line.

My favorite of all the letter flourishes is adding an extra loop to the tail of a "y," "g" or "j." Changing the size and placement of the loop can give you different looks.

There are many more flourishes and variations you can do, but these will give you a great start! Which type is your favorite? Take some time to practice these three styles, then use them to create our reminder that today is indeed a gift.

As you create your design, you'll start by lettering "today is a gift" in a combination of faux calligraphy (page 8) and Whimsical Print (page 24). Then, sketch a rectangular shape around it to create the idea of a wrapped present. Two loops on top will represent a bow, then you can create the streamers by using some of the brand-new flourishes! A few more flourishes at the bottom will finish off the design and give you great practice with these skills. Remember, yours doesn't have to look exactly like my example. This is your time to experiment, to grow as an artist and to create masterpieces that are all your own!

PLAYFUL DOT-STYLE ALPHABET

Friends, as we continue to add skills to your lettering repertoire, it's time to learn a new font to throw in the mix! This style, the Playful Dot-Style Alphabet, is another print font that adds a touch of whimsy and fun to any design. It's incredibly easy to create—if you can write the alphabet and draw simple dots, you're sure to succeed! Let's take a look at how to draw this font and combine it with what you already know.

FEAR LESS

All of us are afraid of something. If you asked me ten years ago what I feared, I'd have immediately replied, "flying." I don't have a logical explanation for why, but I was terrified to step onto an airplane. So I didn't. My fear of flying cost me a great deal. As a teenager, it resulted in my missing an incredible opportunity to take a trip I earned through my local 4-H program. But more importantly, it kept me from being present for my best friend's wedding. Tammy and I were the best of friends from the moment we met the summer before 6th grade. After graduation, we chose different colleges, then four years later she moved to Washington state to pursue her career as a dental hygienist. I stayed in Maryland, on the opposite side of the country. When she asked me to be in her wedding, I said yes, but when the time came, I was paralyzed with anxiety and missed the wedding. It was a tremendous disappointment for both of us and put a strain on our relationship. I determined then that I was going to do whatever it took to overcome my fear so it never held me back again. Thirteen years later, I can say that I've overcome that particular fear with the help and encouragement of my family (and anxiety meds) and have taken multiple flights all over the country. What about you? What fears are holding you back from living your best life?

Let's practice being fearless by diving into this week's workshop and learning a new font for our lighthearted designs!

DOT-STYLE ALPHABET WORKSHOP

This week's lettered phrase combines many of our previous skills, like serifs (page 27), the Whimsical Print alphabet (page 24), advanced banners (page 45) and vines (page 12) with this brand-new font.

The Playful Dot-Style alphabet basically takes the regular printed alphabet and adds a touch of levity with little polka dots at the ends of lines.

STEP 1

First, simply print your word or phrase.

In our design, the word "fear" will be in this font, so that's a good place to start.

STEP 2

Then, add a small circle to the end of each straight line.

STEP 3

Finally, fill in the circles to create dark polka dots.

An even easier way to do this is by taking a marker with a rounded tip that's not too small and creating the dots by simply pressing it down onto the paper and back up. The larger end of the Tombow Monotwin is perfect for this. It gives you instant polka dots without having to draw them and then color them in.

Here's a look at the entire alphabet in playful dot style for your reference. You can form the letters in whatever way you like best, but this is how I write mine. The key is to place your dots at the ends of lines for that lighthearted touch.

ABCDEFGHIJKLMN
OPQRSTUVWXYZ
abcdefghijklmn
opqrstuvwxyz
0123456789

Now, let's look at how to create our "fear less" design. I recommend trying this in pencil before going over it with your markers and pens. First, you'll want to start by sketching a curving banner (page 16) and writing the word "less" on it in Whimsical Print (page 24). Next, add serifs to the ends of the letters for an extra embellishment (page 37). I decided not to color in between the lines this time to give the font a different effect. Next, write the word "fear" in all capitals just above the banner using the new font style we learned in today's workshop. Finally, sketch curving vines (page 12) above and below the phrase to create a circle. You may want to actually find something circular to trace around your message to give it a pretty shape. I found that a coffee mug was the perfect size for mine.

Once you've got your design sketched, fill it in with marker and add your embellishments. Remember, it always takes time to master a new skill, so if yours doesn't look exactly like the example, don't worry! We all have our own style, plus repetition will make your projects turn out better every time. What matters most is the journey and taking the time to relax and create!

SIMPLE SHAPED DESIGNS

Shapes play an important role in art, even in the world of hand lettering. Sometimes certain phrases lend themselves to being represented in a particular shape, which can add both interest and meaning to the overall design. Whether the shape is related to the phrase itself or simply a tool for laying out words in a visually appealing way, the technique is the same. This workshop will get you started with simple-shaped designs that will draw the viewer's eye and add variety to your lettered work.

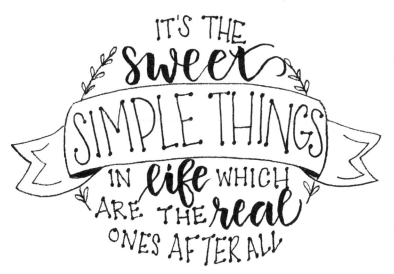

SIMPLE PLEASURES

One of my favorite parts of being a parent is watching my son delight in things. Last winter, we were walking out of the grocery store together as the first few snowflakes of the season were falling. As he looked up at the sky, his eyes sparkled. He stopped walking and twirled on the sidewalk while sticking out his tongue in the hopes of catching a stray flake. It was pure joy, the same thing I see on his face every time we catch a firefly or he picks me a dandelion from the front yard. Children have a way of noticing and enjoying what we take for granted, don't they? It's one of the many ways my son teaches me. When I see his response to things, I'm reminded not to overlook life's simple pleasures. Sometimes we can find the greatest of joys in the simplest of moments, like a baby's laughter or the purr of a contented kitten. When is the last time you stopped to enjoy the little things around you? Today, take a moment to pick a flower or to listen to your favorite song. Put on your boots and jump in a puddle; it's just as fun at 30 as it was at three. If you have trouble finding a reason to smile, just ask a child and they'll show you the way.

As we reflect on those little things in life, we're going to learn how to create a special visual reminder that they're too important to overlook.

SHAPED DESIGNS WORKSHOP

Are you ready to take your lettering to the next level with shaped designs? It's easier than you think!

STEP 1

Trace or sketch your shape in pencil.

We're going to start by creating a circular design, so you'll want to find a coffee mug or small bowl you can trace on the page. For future designs, you can trace or freehand any shape that works well with your quote.

STEP 2

Sketch a basic banner (page 16) slightly above the center of the circle, using the sides of the circle as guidelines for the sides of the banner.

Of course this won't be part of every shaped design you create, but a banner can be a fun embellishment to incorporate. We're using it in this particular quote to emphasize the most important words.

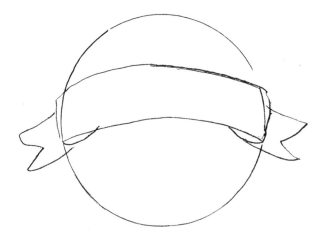

STEP 3

In pencil, sketch out the positioning of your words in such a way that they fit inside your shape.

As you do this, you'll want to slightly curve some words and even some individual letters to help illustrate the shape. You may also find yourself making certain letters longer or shorter than others to help fill the space.

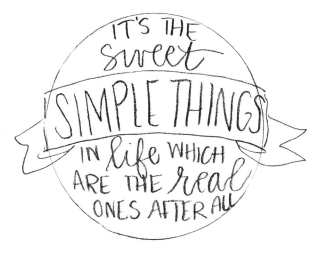

STEP 4

Trace over your design with your marker/pen.

For this particular design, I used faux calligraphy (page 8) for "sweet," "life" and "real" and the Dot-Style Alphabet (page 73) for everything else.

STEP 5

Add embellishments.

Since "sweet" didn't take up the entire space above my banner, I decided to add curving vine embellishments (page 12) on either side to help fill it out and emphasize the circular shape. Another option is to add some sort of small border around your shape, like tiny dots, stars or even coffee beans!

The possibilities for shaped designs are as limitless as your imagination. While many of my own tend to be round because I like the aesthetic the circular shape gives, I've also lettered inside everything from a star to a pigeon! Take some time to practice working with a circle, but also to sketch some shapes of your own choosing and see how you could position a phrase inside.

BASIC BRUSH STROKES

Friend, can you believe how much you have accomplished so far in your lettering journey? You have learned a variety of font styles and embellishments, and hopefully you've been enjoying the fun and relaxation that comes with creating your own lettered art. Today, we're going to shift gears a bit and take your skills to the next level by actually learning the brush technique! The very first thing we looked at together was how to fake this look, but now it's time to master the real skill. It can be a bit of a challenge, so we're going to break it up into doable chunks over the next several workshops. Don't worry if you don't get the hang of it right away, just keep on practicing and I promise it will get easier. Before you know it, you'll be brush lettering like a pro! Today, we're going to start by focusing on how to create the two basic brush strokes you'll be using, upstrokes and downstrokes.

MISTAKES MEAN YOU'RE TRYING

For many people, mistakes are a sign of failure. They are something to avoid at all costs, and if they do happen, they're something to hide. I'm not sure how that mindset became such a popular one, but it can be incredibly toxic. You see, if we're afraid to make mistakes, there are challenges we'll never attempt. Over the years, as I've experimented with learning a wide variety of art forms, I've found that messing up is inevitable. I'm not perfect, so how can I expect perfection in the designs I create? Mistakes are the natural result of stepping out and doing something, even if it turns out differently than we expected. They're a sign that we tried something, and we can learn from them as we move forward. I don't know about you, friend, but I would rather do something imperfectly a thousand times and finally get the result I wanted than never have done it at all. How do you view the mistakes you make? Are you willing to persevere and work through them, learning as you go?

As we move into our first brush lettering workshop, remember that mistakes are opportunities to learn, and as my son's teacher says, "mistakes make your brain grow!" Let's get started.

BASIC BRUSH STROKES WORKSHOP

The key to the brush lettering technique is changing the position and pressure of your pen as you write. It sounds so simple, yet mastering the technique can be a real challenge and just plain frustrating at first! My best advice is not to give up. Practice makes progress and every time you practice, you're getting it into your muscle memory, just like riding a bike, dancing or anything else you do. And to be clear, YES you need a BRUSH PEN. A regular pen, pencil or marker will not work for this technique. Some artists use a paintbrush, which we'll explore in a later workshop, but for now a brush pen is our tool of choice.

Before you can write words, you have to write letters. Before you can write letters, you have to write lines. Brush lettering is characterized by thick lines on the downstrokes of letters and thin lines on upstrokes. That means each time you move your pen in a downward motion, you have to create a thick line based on the angle of your pen and the amount of pressure you use. So far so good?

Take your brush pen and hold it at about a 45-degree angle to the paper. Using firm pressure, make a series of downstrokes to get a feel for this. Don't worry about pushing too hard; your pen was made to do this. Keep on going and making these lines. They should be similar in width because you're applying the same amount of pressure.

Once you've got a page of downstrokes, it's time to tackle the thinner line, the upstroke. This time, you'll be holding your pen a little higher off of the paper, closer to 90 degrees than 45. We only want the tip of the pen to draw this time, so the less of it that touches the paper, the better. We're going to use lighter pressure and move the hand in an upward motion. The brush tip will still flex as you move it, but you'll get a thinner line.

Horizontal lines are done the same way, with light pressure and just the tip of the pen on your page.

I really want you to play around with these lines and get a sense of how it feels to create them. In your sketchbook, try making your lines vertical as well as diagonal. Make a series of downstrokes, a series of upstrokes, and then when you're starting to feel like they're pretty consistent overall, it's time for a new challenge—alternating them. Down, then up, down, then up. I'm completely serious when I tell you to fill a whole page (or two or three) with this. The more your hand does it, the more your muscles will remember how.

MOVING ON TO LETTERS

I know, I know. You want to write in the fancy script. We all do. That's why you wanted to learn this in the first place. But here's the thing. The way some of those letters are formed isn't the same as the way you naturally form them in your own handwriting. So you'd have to learn this new technique plus the new letter shapes simultaneously, and that doesn't set anyone up for success. Instead, we're going to start by simply combining the straight lines you just learned how to make and creating some basic uppercase print. This will allow you to practice on something you're already comfortable with, plus you can always combine print and script in your projects to make them more interesting.

Ready? We're going to start with a capital "T." All you have to do is make a vertical downstroke and then a thin horizontal stroke to top it off. Make a whole row of fabulous "T's."

T T T T T T

Now we're going to step it up a bit and try combining upstrokes with down. To form a capital "A," you'll make a diagonal upstroke, a diagonal downstroke and a horizontal cross bar. You can pick your pen up in between the up and downstrokes, but eventually you'll want to just keep it moving on the paper and change the pressure as you go. Time to make a bunch of these "A's"! You'll notice that every now and then one will turn out less awesome, but that's how this works. It happens to me too, and I'm the professional, so don't worry about it, just keep going.

A A A A A A ↑A↓

Here is a list of capital letters that are great for practicing these strokes. Play around with them and fill pages of your sketchbook with them.

AEFHILMNTVW

LETTERING BASIC WORDS

Let's take some time to combine the letters you've been practicing into a few simple words. You can even make funny sentences if you like: The tan teen team ate lean meat. Amuse yourself!

THE · ATE · LET
TEAM · MEAT · TELL
MEET · TEN · LEAN
NET · NEAT · LANE
TEEN · MEN · MALL
NAME · AT · TAN
TAME · MEANT

In case I haven't emphasized it enough, practicing these strokes is the absolute key to your success at brush lettering. Once you can do this, you can write anything. I promise not to leave you hanging here, we're going to move on step by step in the next few workshops to look at how to handle curved lines and yes, how to form those lovely script-style letters we all adore. In the meantime, get to work, cupcake! The more you practice, the more you'll progress. Promise.

To create our featured design, I want you to focus on using this brush technique to print the word "MAKE." Below it, write "mistakes" using faux calligraphy (page 8), then give the whole phrase a ribbon border (page 62).

BRUSH LETTERING: LEARNING CURVES

Mastering the technique of brush lettering is definitely not something that happens overnight. It's a process that involves practice and repetition as you develop the skills necessary to form letters and words. In the last workshop, we looked at the basics of how to use a brush pen to create thin upstrokes and thick downstrokes. But what happens when we're writing a letter that's not composed of straight lines? Today, we're going to learn how to handle curves while maintaining the proper pen pressure to form each type of stroke. Once again, we'll start simply and build on the skill until it becomes second nature. Believe it or not, brush technique can be an incredibly relaxing and stress-relieving exercise once you've mastered it!

CELEBRATE THE SMALL THINGS

In my family, we love to celebrate birthdays all month long. Christmas is one of our favorite days of the year, and we always look forward to spending the 4th of July eating crabs with family. (We're from Maryland, you know!) But we don't stop there. We also celebrate the small things because we've learned that life is just more fun that way. For example, when Little Crafter (my son) loses a tooth, it's a great day to go out for ice cream. Sometimes we have family movie and game nights to celebrate a job well done at work or school. Other times, we go out for a treat, whether it's edible or a new toy. We make cards for each other to recognize accomplishments. There are countless ways to do it, and many of them are even free. Each time we celebrate, we make memories as a family that will last a lifetime. What are some of the small things you can turn into special occasions?

One thing that's worth celebrating is how far you've come in your lettering journey! Can you believe you're on your way to mastering brush technique? Think of a fun way to treat yourself for all you've accomplished. Then, let's jump back in and take a look at how to create curves.

BRUSH LETTERING: CURVES WORKSHOP

We're keeping things very simple for this design, because I want you to focus on the brush technique itself. Since we haven't covered all the letters and techniques yet, writing the whole word "celebrate" may present a challenge, but never fear. Use your brush skills for the letters you know, then fill in the rest with a bit of faux calligraphy. It'll be our secret.

DOWNWARD CURVES/UNDERTURNS

Now, let's learn about these curves, shall we? The first thing we're going to do is make a downward curve, or underturn. All we're doing is connecting your downstroke with an upstroke. It's similar to what you did when you made a capital "V" or "W"—we're just not going to pick up our pen. Place your brush pen at a 45-degree angle to the paper, apply pressure and start making a downstroke. As you get to the bottom, start to release the pressure and switch to an upward motion to create an upstroke on the other side. This will create a "U."

Trust me, I know your first few won't look fabulous. When I started out, mine were pretty terrible, honestly. But as you practice, you'll start getting the hang of where and when to release pressure and you'll get underturns that look like the ones below. Honestly. I want you do to this over and over and over again: It may be repetitive, but that's what it takes to teach the muscles in your hand how this works.

UPWARD CURVES/OVERTURNS

Now that you've tried some underturns, we're going to reverse things and do upward curves, or overturns. Instead of transitioning from a downstroke to an upstroke, we're going to start by going up and switch halfway to using pressure and going down. This is very similar to making the capital "A" (page 83); we're just rounding the top a little to make the connection more fluid. Now what? You guessed it . . . make a whole page or two or ten that look like this!

COMPOUND CURVES

Now comes the really fun part. We're going to put the underturns and overturns together into one big squiggle! Start with a downstroke, make an upward curve, then a downward, another upward and continue on like so.

Don't worry about them all being the same height, just play around with keeping your hand and pen moving the whole time. Do this over and over so that you get comfortable with the motion. For future reference, we're going to call one downward curve plus one upward curve a compound curve.

Got that?

Guess what? Those compound curves you made? You were actually forming letters in there, you just didn't know it! I know we started with print, but right this moment, it makes sense to spend a few minutes forming some script letters.

U

Make a compound curve. Start with an underturn, then make an overturn that's a little bit more closed. You just made yourself a "u." Check it out!

u u u u u u u

Pretty snazzy, huh? Now make a million more of them.

N

Now we're going to make the same compound curve, but we're going to make the first overturn a little tighter and go up on more of a diagonal. Instead of a u shape, we get a script "n"!

n n n n n n

M

This time, we're going to take it up a notch and make TWO compound curves. Like we did for the "n," we're going to keep the underturns tight, almost pointed. And we get . . . the letter "m"! Look at you, lettering!

m m m m m m

As you make a million practice ones, feel free to play around with the height of the curves. A lot of lettering artists like to make the first "bump" of the "m" higher than the second to stylize it and make it look definitively like the letter and not just squiggles. See what you like best!

V

Take a look at the left side of your letter "m." That is exactly what we need to do to create the letter "v." A tight underturn gives us the shape, then a little loop on the end finishes it off!

v v v v v v

W

Last but not least (for now!), we're going to create a "w." This time, we'll make a compound curve and a half. That means we go down, up and down, but when we get to the top with our last upstroke, we're done. Well, after we get a bit fancy, that is! If you want to just pick your pen up, you can, but it's more fun to add a little loop instead!

w w w w w w w

Now it's time to . . . you guessed it . . . make a page of "w"s! Remember: Practice makes progress!

Once you're done practicing the strokes and individual letters, feel free to move on to the lettered phrase "Celebrate the small things." Remember, we're not looking for perfection here, just your best. Then be sure to celebrate your progress.

BRUSH LETTERING: ROUNDED LETTERS

How is your brush practice going, friend? I hope you're finding it relaxing and therapeutic rather than frustrating. Keep in mind that it's just like any new motor skill and requires repetition to become part of your muscle memory. We're not striving for perfection, just progress! So far, we've looked at how to create basic brush strokes and how to curve them. Today, we're going to build on those skills even more and turn those curves into rounded letters.

LEARN SOMETHING NEW EVERY DAY

For many of us, it's been years since we set foot in a classroom as a student. But learning doesn't stop when we walk away with a diploma. To challenge our minds and keep us fulfilled, one of the best things we can do is commit to being lifelong learners. We can read about subjects that interest us, take a local dance class or check out DIY videos on YouTube. Many libraries and community centers offer free seminars on all kinds of topics. In fact, you're learning right now as you read and practice your way through this book! As you continue to learn new facts and skills throughout your life, you'll find that it benefits your mind and body, not to mention the fact that you'll be able to do so many wonderful things. What are you most interested in learning right now? Besides hand lettering, that is!

In the meantime, let's keep your brain and hand busy with more practice on the brush technique as we tackle rounded letters.

BRUSH LETTERING: ROUNDED LETTERS WORKSHOP

The design we'll be lettering incorporates not only brush lettering, but also some fancy flourishes. Although they're not letters themselves, flourishes work in the same way when it comes to brush pressure and angles. Play around with them and see what happens when you try applying this technique to the rounded and curving lines of the flourishes as well as the letters of the phrase itself.

Learning to create rounded letters actually isn't too far off from what you did when you were creating the underturns and overturns. The only difference is that we're going to round off the tops and bottoms a bit. Place your pen on the paper and instead of making a line straight down, curve it out to the left while still applying pressure. When you get to the bottom, release pressure like before and start your upstroke. At the top, apply pressure again and curve your line out to the right. This will create something that looks like a sideways "s."

The curved parts on either side should be your thickest lines because those were downstrokes, while the part in the center should be thinner. Practice this to get a feel for how your pen handles the curves. And remember, it's art, not an exact science, so don't get frustrated when each one looks a little different. The more you do this, the more the technique gets into your muscle memory, so keep going!

A

Now that you've practiced the technique, let's look at how it applies to some of our script letters. We'll start with an "a." Begin just like you were doing in the practice exercise, but when you get to the top of your upstroke, you'll come straight back down instead of making another curve.

As you practice, play around with how far apart your downstrokes are. In the example on the far left, you can see that I left more space, whereas on the far right, I kept my lines much closer together. Personally, I like them closer because I feel that it looks more definitively like an "a," but there's no right or wrong to it, just style.

O

Next, let's look at the "o" shape. Again, we're going to start out the same way we did for the practice exercises, but this time when you get to the top of the upstroke, continue it up and around to cap off the "o."

C

Creating a "c" means starting the same way but stopping shortly after you start your upstroke. This one can actually be a little tricky; sometimes I have trouble releasing pressure soon enough on my upstroke and my line is thicker than I want it to be.

G & Q

The other rounded letters we're looking at today are extra fun because they have tails! "G" and "q" start exactly like an "a," but instead of ending our line, we continue that second downstroke about twice as long and then finish it off with a little loop. This is called a descender loop stem.

g g g g g g g

q q q q q q q

Each of these letters takes time and practice to feel comfortable. Even now as a professional lettering artist, I still spend time filling pages with letter practice to sharpen my skills.

I, T & X

Here's a quick review of the letters you should be practicing . . . "i," "t" and "x" make use of simple, straight lines.

i t x

These letters are variations of our underturns, overturns and compound curves.

m n u v w

And these letters use the rounded technique we practiced today.

a c o g q

Next time, we'll talk about loopy letters like "l," "b," "d" and "k"; some of my favorites. Until then, practice makes progress! Use the space below to practice using brush technique to write the rounded letters. Then, when you're ready, go ahead and letter today's design. Remember, use the technique when you can, and fill in anything you can't figure out with a little faux calligraphy. It will be our secret.

BRUSH LETTERING: LOOPING LETTERS

By now, friend, I hope you are feeling comfortable using your brush pen and creating all kinds of lines, whether they're straight, curving or rounded. In this workshop, we're going to take what you already know and apply it to form loops so that you can write letters like, "h," "b," "l" and "d."

RISKS AND REGRETS

Some people live their lives looking for the next thrill. They seek adventure and crave the rush of adrenaline that comes from taking a risk. Perhaps you are one of them. Or perhaps you're more like me and prefer to carefully evaluate a situation rather than rushing in headfirst. But, what I've learned over time is that most of the things you'll regret in life are risks you didn't take. Some of the best experiences that have ever happened to me came after I stepped out and did something I was afraid to do. Ten years ago, I quit my job as an English teacher to pursue more creative outlets. It was terrifying. I mean, teaching was what I was trained to do. I had my college degree and was putting it to use to earn a good salary. I had no idea what would happen once I walked away. Would I make money? Would I be happy? It took time, but the answer to both of those questions was yes. I was immediately happier, because I was working for myself, on my own schedule and doing what I loved. And as I built my brand and my audience, the money eventually came too. Last year, my blogging income surpassed what I was making as a teacher. It's always easier to stay in our comfort zones, but great things only come when we step out and see what can happen. It's never too late to take that risk, pursue that hobby, change a career or make a move. Could it fail? Maybe. But you'll never know if you don't try!

Speaking of trying, it's time to apply your new skills with the brush pen to a new type of letters. Let's take a look at how to make loops.

BRUSH LETTERING: LOOPING LETTERS WORKSHOP

Our design for this workshop is again fairly simple so that you can focus on putting the brush technique to use. We are going to letter inside a shape and combine your brush skills with a bit of Whimsical Print (page 24).

By now, you should be very familiar with our starter brush exercises; thick downstroke lines and thin upstrokes in straight lines and curves. Just to refresh your muscle memory, make a few of these long squiggles to get your pen going.

L

Now, we're going to start with the upstroke part, but instead of curving back down to the right like we did before, we're going to take our pen in the opposite direction and make a downstroke that crosses our existing line. This will form an "l." Remember, they won't all look the same. Don't stress out over making them perfect, just make them.

As you start to get a feel for it, play around with the size of your loops. You can see that on the second line, I alternated small loops with larger ones. There's no right or wrong to loop sizing, it's all about your own style and what you like. Personally, I tend to use big open loops on my letters, but I know artists who do gorgeous work with small ones, too.

H

Once you've practiced your "l" we can move on to the "h"! It's built with two pieces you already know: a loop and a compound curve (squiggle).

Form a loop like the ones you just practiced, then without picking up your pen, make a compound curve plus an underturn.

See? Piece of cake!

B

After you've gotten a feel for the "h," it's not too much different to write a "b." Once again, you'll create a loop then a compound curve, but instead of curving back up at the end, you'll wrap the tail around the opposite direction as shown below. You can make your loop as open or as closed as you like.

K

The "k" is another similar letter to create, although for some reason, it's one of my least favorites. I keep trying to come up with a look I like better, but for now this is what I do.

k k k k k k

E

Creating an "e" is simple once you've mastered the "l." Simply begin an upstroke at the center of where you want your letter to be, then create an upward loop that continues around and down.

e e e e e e e

F

"F" is a fun letter to create because you get to combine an upward loop with a tail!

f f f f f f

D

The final upward loop letter "d" is different from the rest, because rather than beginning with a loop, it comes at the end. Again, it's composed of two parts you already know how to create. Start by making a rounded letter, just like you would with an "a." Then, as you curve up at the bottom, make that the upstroke of your loop. Make sense?

Now it's time to practice that over and over and over again. Feel free to play around with the size of your loops and find your favorite style.

d d d d d d

Use scrap paper or a few pages in your sketchbook to work on these particular letters, getting a feel for the technique. The more you do it, the easier it will become, I promise.

When you're ready to create the final design for this workshop, you'll want to start by tracing something round, like a coffee mug or a small bowl, onto your page to create the basic shape (page 77). Do this in pencil so you can erase it when your art is complete. Still using your pencil, lightly sketch in the placement of your words. Once they are arranged, go ahead and use your markers and brush pens to trace over them. I added a few embellishments to fill out the circle and suggest the whole shape once my pencil lines were erased. Once again, the focus here is on letting yourself use "real" brush technique as much as possible. For letters you haven't learned yet, like "r," feel free to use faux calligraphy (page 8) or to challenge yourself and see if you can work it out using the technique tips you already know. Whatever you do, don't pressure yourself to be perfect. This is all about enjoying the journey as you learn something new. Just relax and have fun creating.

BRUSH LETTERING: LEFTOVER LETTERS

Believe it or not, we've made it to the final workshop in the brush technique series! In the past four sessions, you've learned to control the angle and pressure of your pen, and to form straight, curving, rounded and looping letters! That leaves just a few leftover letters we haven't covered. Today, we're going to look at how to apply the techniques you already know to form those so that you have mastered the entire lowercase alphabet in brush script! Hopefully, by now you're starting to feel more comfortable with the technique and applying it to your lettered art on a regular basis.

PEOPLE-PLEASING AND PIZZA

I absolutely hate it when someone is upset with me. I've been a people-pleaser all my life. On the plus side, it kept me motivated to work hard, get good grades and stay out of trouble. But there can be a negative aspect to this mindset too. I almost didn't make a major career change because I was so worried about what everyone would think. Being a people-pleaser can also be incredibly stressful when someone does get upset. I feel the need to do whatever is necessary to fix it, which gives someone else way too much control over my life. Do you resonate with this at all? Do you find yourself worrying about others' opinions or making decisions to please the people around you? If so, let me tell you something I'm trying to teach myself. You can never make everyone happy. It's true. There's literally no way that every person on the planet will always love you. Inevitably, you'll face conflict . . . and that's okay. There will always be someone whose personality just doesn't click with yours. That's okay too. It's time to give ourselves permission to not please everyone all the time. After all, we're not pizza, right?

As we get ready to create a hand lettered reminder for ourselves, we need to take a minute to learn brush technique for the remaining five letters in the alphabet. After all, you can't write "pizza" without "p" and "z"!

BRUSH LETTERING: LEFTOVER LETTERS WORKSHOP

Let's have some fun with this workshop, shall we? By the end of this tutorial, you will officially know how to form every letter of the alphabet using brush technique, so we're going to put it to the test.

In the previous four workshops, we've covered straight, curving, round and looping letters. Now, it's time to finish up with a look at five letters that don't fit neatly into just one of those categories.

Y

Let's start with the letter "y." It begins like a curving letter and ends with a descender loop stem like some of our rounded letters do. First, make a "u." Then, instead of curving your last line back up, let it keep coming straight down past the bottom of the letter. Finally, loop it back around.

There you have it, a pretty "y"! There are all kinds of fun embellishments you can add to the tail eventually, but for now, let's spend some time repeating the basic letter formation.

S

Remember the exercises we did when learning how to create rounded letters? Take a minute to draw a few of those going in both directions.

Now, we're going to make a compound curve and flip it 90 degrees, and there's our "s"! Simply finish it off by looping back up at the end. This is one of my favorite letters of all, so have fun drawing a bunch of these.

R

It's time now to revisit our basic looping letters exercise. Draw a few "l" shapes, then as you go along, gradually let the loop become smaller and smaller. Extend the tail out to the right, and finally finish with a downstroke to create the "r."

J & P

To form a "p," first you'll start with a descender loop as though you were writing a letter "j." Instead of stopping, continue on around and add a loop at the end just like you do for the letter "b."

Z

That brings us to our final letter, "z." You'll begin by making a downward curve, then another that finishes with a tail.

This is one of the letters you'll use the least, but you still want to become comfortable with it in case you want to write about something important, like pizza.

Now we have officially covered the whole alphabet! Here is a quick review of what the letters look like in brush script, as well as which letter type they are. This way, if you're struggling with a few particular ones, you'll know which workshop to reference to brush up your skills.

STRAIGHT
ROUNDED
LOOPING
CURVING
SPECIALTY/LEFTOVER

Here's a look at the alphabet in both upper and lowercase letters, written with the Tombow Fudenosuke Soft Tip Brush Pen.

abcdefghijk
lmnopqrst
uvwxyz

ABCDEFGHIJ
KLMNOPQR
STUVWXYZ

As with the other letters, it's going to take some good old-fashioned practice and repetition before these feel like second nature. There's no time like the present to start repeating those shapes, paying special attention to the angle and pressure of your pen. Once you're feeling more comfortable with the new letters, creating the design will be a piece of cake. Start by drawing some horizontal guide lines in pencil, then letter the phrase using a combination of brush script and Whimsical Print (page 24) as shown in the example at the beginning of the workshop. Then, sketch two triangles to represent pizza slices and add basic shapes for toppings. Go back and add your lettering with the brush pen. If you'd like, feel free to trace your design.

CREATING DIMENSION WITH SHADOWS & HIGHLIGHTS

Have you ever seen a piece of lettered art that looks like it's literally hovering over top of the page? It's definitely an eye-catching effect, and it's easier than you might think to achieve. By using some simple shadowing and highlighting techniques, you can give any word a three-dimensional effect. There are several ways to create shadows and highlights, but all of them are easy to learn and put into practice. Today, we're going to look at the basic techniques and talk about how you can create your own variations. All you need is a gray marker and a white marker or gel pen, and you're ready to make your lettering pop right off the paper.

NEVER STOP SHINING

Summer evenings were always my favorite as a little girl, because we would go out onto the back porch and catch fireflies. It felt so magical when the first light appeared, followed by more and more until the whole yard was filled with their glow. You could chase them, catch them, hold them, even put them in a jar and they just continued to shine their little lights. Now my son is the one with the net and the jar, but the fireflies are the same. No matter what happens, they just keep on shining and doing their part to light up the dark. It seems to me that you and I could learn something from the fireflies. There are plenty of things that happen in our lives that try to keep us from shining. All of us face obstacles in our paths and hard times, and in those moments, we have a decision to make. Will we let them get the best of us or will we shine on anyway? Even through rejection and disappointment, will we keep on shining our own unique light?

As we reflect on how important it is to keep shining, let's learn how we can make our letters do the same.

SHADOWS AND HIGHLIGHTS WORKSHOP

To create this design, we'll be combining your new brush lettering skills with some shadow and highlighting techniques. The easiest way to create a dimensional effect is by adding simple gray shadow lines. All you need is a gray marker . . . my favorite is the Tombow Fudenosuke Twin Tip Black and Gray because the one pen has both tips I need!

STEP 1

Start by writing the word or phrase, in whatever font you choose.

For this design, we're using brush lettering.

STEP 2

Go back with the gray marker and add lines just to the right of the existing ones, the same way you did when creating the Bold 3D font (page 50).

The gray lines will take on the appearance of shadows, making your word seem to jump off the paper.

BASIC HIGHLIGHTS

For this technique, all you'll need is a white gel pen. Write your word or phrase as you normally would and be sure to let the ink dry. Then, go back with your gel pen and add highlight lines. My go-to pattern is to do three little dots and a longer line. If a letter is particularly long I might add three more dots at the end. If it's especially short, I might do one or two dots instead of three.

This technique works on both black lettering and colored, as long as the base color is dark enough that the white pen is visible. If not, use a darker color for a different effect.

DRAMATIC SHADOW

For an even more enhanced shadow effect, leave a bit of space between your letters and the shadow lines.

COLORED SHADOWS

For a different shadowing effect, instead of using gray, you can try a color that's darker than whatever color you used for writing. Typically, I choose a darker shade of the same color, but you can also choose something that's within the same color family. I like using the thin end of my Tombow Dual Brush Pens for this. Once again, I go to the right of the lines in my letters, as you can see in the example below.

DOUBLE SHADOWS

These effects can be combined too. I wrote the word "shine" using the brush end of a Tombow Dual Tip marker, then used the thin tip of a darker marker to add accent lines. After I had done that, I went back and added gray shadows to the right of those darker lines to really give a three-dimensional effect.

I enjoy playing around with color combinations and seeing what different looks I can achieve. Shadowing is one of the easiest ways to make certain words really stand out in a phrase.

COMBINING EFFECTS

Now if you really want to go all out, combine all the effects together. Add colored shadows, gray shadows AND highlights for a look that really makes your lettering vibrant!

It's time to pull out your colored markers and give this a try! When you're ready to create the featured design, you'll want to start by sketching out the position of your words. You can follow my example, using the sample image as a guide, or space them out in any way you like. Next, trace over all the words except for "shine" with a black brush pen like the Tombow Fudenosuke. I printed "eat" and "for" then used brush script for the rest. After, choose any color brush marker and letter the word "shine." Finally, add shadows and highlights using the skills you learned in this workshop.

POSITIVELY AWESOME NEGATIVE SPACE DESIGNS

Typically, when we think of a lettered design, we imagine a word or phrase written in black or colored marker. But there's another type of design we can employ in our art that makes use of negative space instead. Negative space is the "blank space" on a page that is around and between whatever we draw. We can make use of that as artists by manipulating the negative space to become our desired image itself. It's the opposite of what our minds and eyes expect, so it can be a powerful design tool for our creations.

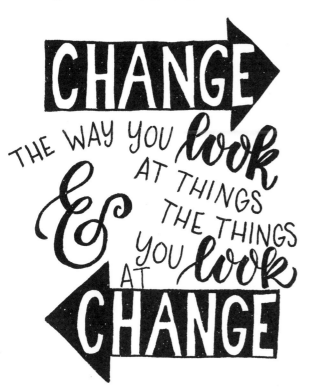

CHANGING YOUR PERSPECTIVE

When my son was small, he loved a book called *Duck! Rabbit!* The focus of the story is a hand-drawn shape, and two off-page voices debate about whether the shape is a duck or a rabbit. Each voice offers reasons to support its opinion, and what's fascinating is that either . . . or both . . . could be right! It all depends on your perspective. From one angle, the shape looks just like the side view of a rabbit's head with its ears pointing straight back, but from the other perspective, the "ears" are actually a duck's bill. In the end, the answer is never given, you get to decide for yourself what you see. Life is a lot like that book, isn't it? Many situations in life aren't clear-cut. Taking the time to look at them from many angles and consider all the possibilities will show us things we couldn't see before. Listening to the perspectives of others can help us realize there's more to a situation than meets the eye. In the end, just as in the book, the decision is ours. How we see the people and situations around us is our choice. What will we do with it?

Ready to create in a new way today? Let's jump in to this week's workshop.

NEGATIVE SPACE WORKSHOP

When we change the way we look at things, the things we look at tend to change. That's the reminder we're going to letter for ourselves in this workshop. Negative space designs pair perfectly with shaped designs, so we're going to employ both techniques, along with our ampersand and a bit of brush lettering.

The shape we'll be working with for starters is an arrow, but of course you can use any kind of shape for future designs. To create a negative space design, you'll need a pencil, a straightedge, an eraser and a black marker.

STEP 1

Use a pencil to sketch your shape.

I recommend using a ruler or other guide to help keep your lines straight. I actually traced the small rectangular window in the ruler that comes with Tombow Fudenosuke pens and it was the perfect size. Then, I added a few lines to turn the rectangle into an arrow.

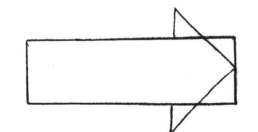

STEP 2

Lightly write the letters of your word inside the shape.

Don't worry about style yet, just position. Make sure you can get your word to fit. I just printed in all capital letters.

STEP 3

Turn your printed letters into block-style letters.

STEP 4

Use your marker to trace the lines of your shape and your letters.

The fine end of a dual brush marker or any marker with a small tip will work for this step.

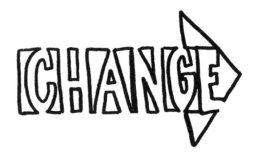

STEP 5

Color in all spaces that are not letters.

Once your design is fully colored, erase any remaining pencil lines.

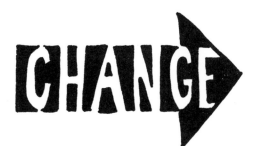

Isn't this a great effect? Now it's your turn! Use the space below to follow these steps and work on a few arrows of your own. Then it's time to letter our phrase. You'll be using two of these arrows, along with a plain print and some brush script to create the design. I started by sketching my two arrows, then filling the rest of the phrase in between. You can model your design after mine or feel free to position your words in any way you like.

BASIC PRINCIPLES OF DESIGN

At this point in your lettering journey, you have an assortment of tools to choose from as you are creating your art. In this workshop, we're going to take a break from our recent emphasis on technique and look instead at how to create designs as a whole. One of the most challenging parts of creating lettered art for many people is figuring out how to arrange words and embellishments on a page in a visually pleasing way. To help make that step a little easier, we're going to learn about some basic principles of design to consider as you sketch out your art: unity, balance, scale, dominance and contrast.

FINDING YOUR STYLE

When I got married, it was the first time I'd ever lived anywhere but my parents' home. I was a senior in college, but I had commuted, so all I'd ever been responsible for decorating was my bedroom. Suddenly, I had to make a million decisions, and I had no idea what I was doing. I bought things that looked similar to what was in my parents' house because it was all I knew. I hadn't yet had the opportunity or the life experience to find my own style. Over the past fifteen years, as I've visited many friends' homes and found a host of inspirations online, I've discovered what I really love . . . and it's nothing like the style I grew up with. I have an obsession with painted furniture and gravitate toward anything coastal or geometric. Over time, piece by piece, I've created a home that reflects those things. Finding your style, whether it's home décor, fashion or hand lettering, is a process that takes time. It involves looking at what's out there and deciding what you like as well as what you don't and trying different things. Gradually you'll begin to notice patterns and your style will become clear. As you continue in your hand lettering journey, take time to evaluate what your favorite techniques and fonts are and you'll start to see your very own style emerge.

One thing that will define your style is how you design your pieces, so let's dive into this workshop, shall we?

DESIGN WORKSHOP

This quote by Rachel Zoe really sums up what our style does. It tells others something about us before we even meet. Let's talk about five essential elements of design and take a look at how they work together to create this piece.

UNITY

As you plan how to position your letters, what fonts to use and what embellishments you want to incorporate, keep in mind that **the ultimate goal is to create a cohesive whole.** Although a design is made up of many parts, they should all be working together to complement each other. One thing that helps create unity is repetition. Repeating a font or decorative element throughout a piece gives a feeling of consistency. You'll know you have achieved unity in your design if it looks like one entity rather than a random assortment of jumbled parts. This doesn't necessarily come naturally, so you may have to play around with things at first, rearranging them and sometimes even starting over until you create something you like. As you design more art, though, you'll begin to get a feel for what works and what doesn't.

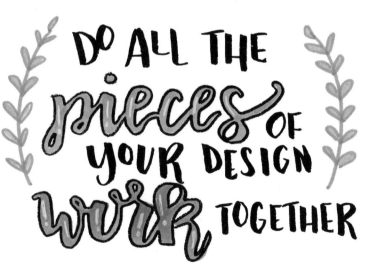

BALANCE

Another key to creating unity in your design is making sure things are balanced. Balance in art refers to the distribution of visual weight and interest within a work. Basically, if you group everything that's big or bright or interesting all in one spot, your viewer's eye will get stuck there instead of traveling all over the piece. Making use of symmetry is one way to balance things, but you can certainly balance an asymmetric design as well. Just be careful to spread things out rather than overwhelm one area.

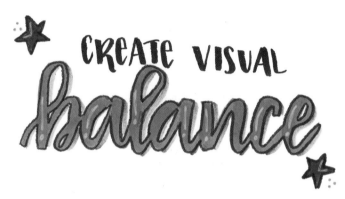

SCALE

Size matters . . . at least in the world of art and hand lettering. As you choose how and where to position your words, keep in mind that **viewers pay more attention to bigger letters.** Read through your phrase and think about what words are most significant. What do you really want people to notice and remember? Those words should carry the most visual weight in your design. You can accomplish that by making them taller, wider or bolder than the rest. Less significant words can be smaller and lighter so they take up less of the viewer's focus. In addition to properly sizing your words, pay attention to the size of the embellishments you're using. Make sure they're complementing your design rather than overwhelming it and stealing attention away from your words.

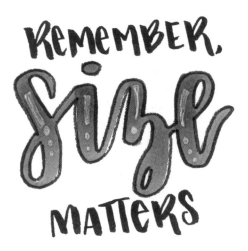

CONTRAST

The amount of visual contrast in a piece of art contributes to the overall mood it creates. Works with high contrast are exciting and vibrant, while works with less contrast tend to be more reflective and soothing. The most obvious way to create contrast is by the use of different colors. There's also contrast in terms of size, style and dimension. As you plan how to organize your piece, think about what type of feeling you want it to elicit and make sure that the amount of contrast is appropriate for that mood.

DOMINANCE

In any piece of lettering, you will **have a focal point**. This is what draws the viewer's eye, and should be the most important part of your design. There are many ways to create this dominance and let people know where the emphasis is in your art. Using color is one way to call attention to a word, especially if the rest of the lettering is black and white. Shadowing and highlights provide dimension that draws the eye, and placing a word inside a frame or banner leaves no doubt that it is important. Size and location also play a role in adding significance to a particular part of your phrase.

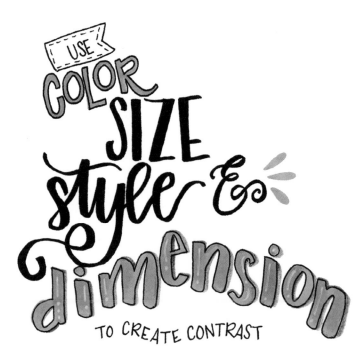

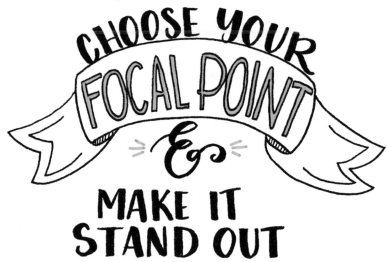

As you create today's quote, pay attention to how these elements are at work in the design. How is it balanced? What is the focal point and how is it distinguished? What type of contrast is used? Also, feel free to tweak the design to reflect your own personal style or to redesign it altogether! Use the practice space below to try variations based on your unique style and preferences.

Personally, I chose to start by writing the word "Style" in a large, colorful brush script. I also outlined it and added shadows and highlights (page 103) to really make it pop. Then I lettered the rest of the quote using a combination of brush print and script, adding highlights to the words "who you are." Finally, I drew some colorful flourishes (page 68) at the bottom to help visually balance the quote.

PRETTY BRUSH-STYLE PRINT

The brush technique you've been practicing certainly creates a beautiful script font, but did you know that's not all you can do with it? Using the same pen and controlled pressure, you can also create a fabulous print font that works well in just about any design. It's a perfect complement to the brush script, and it also pairs nicely with many of the other font styles in your toolbox.

PLAYING DRESS-UP

I remember my first pair of high heels. They were made of pink plastic and had big fake gems on the top. I was only allowed to wear them inside the house, and it took less than a week before one of them broke, but I loved them like crazy. When I put them on, I felt so very fancy! I imagined myself dressed in a beautiful gown just like Cinderella. Those shoes made me feel elegant and graceful even when I wasn't. Playing dress-up does that, doesn't it? It gives us a chance to pretend and to feel different for a little while. Maybe that's why most of us never quite give it up. Maybe dress-up for you doesn't look like a Cinderella gown, it looks like a cape and a superhero mask. But whatever form it takes, it allows us to imagine a different reality. We get to use our imagination and be anything we want to be! Friend, don't ever stop letting yourself do just that. Let yourself be a princess for a while instead of the mom who has a pile of dishes and laundry to do. Let yourself be the superhero saving the day! Enjoy the fun of pretending and letting reality be a little less real. And hey, if you need to vacuum wearing heels or a cape, I'll never tell.

Now, let's put that imagination of yours to work as we get ready to create a whimsical design!

BRUSH–STYLE PRINT WORKSHOP

Today we're going to be lettering a great quote from one of my favorite designers, Kate Spade. We'll be using brush script as well as this new brush print, along with some fancy flourishes.

Are you ready for some wonderful news? You have already mastered the technique you need to create this font, or at least you're well on your way! Let's quickly review what you will want to keep in mind as you use a brush pen to write these printed letters.

Remember, any time your pen is moving in a downward motion, you'll want to apply pressure and keep the pen at about a 45-degree angle in relation to your paper to create a nice thick line. When your pen moves back up, release the pressure and change your pen angle so that it's closer to 90 degrees. These changes should give you a thinner line that provides contrast to the downstrokes, just like in brush script lettering

Here is a look at the alphabet, both upper and lowercase, written in brush print style.

ABCDEFGHIJKL
MNOPQRSTUVW
XYZ
abcdefghijklm
nopqrstuvwxyz

I think you'll find printing with brush technique to be a breeze now that you've been using it in your script. Depending on how you use brush print in a design, it can look elegant or just the opposite, totally playful. For another variation on this font, you can always add serifs to the ends of your lines. Take some time to practice forming these shapes, paying attention to where the up and downstrokes are and using your brush pen accordingly. Then move on to creating the featured design!

First, you'll want to sketch four straight lines for your text. Pencil in your words, using brush script for "dress-up" and brush print for everything else. To embellish the quote and give it a whimsical feel, add four flourishes (page 68) and a crown (or a superhero mask if that's more your style). Go over your quote in marker, coloring the embellishments, and just have fun with the design.

WORLD'S EASIEST WATERCOLOR BACKGROUND TECHNIQUE

Some of the most beautiful pieces of hand-lettered art incorporate colorful watercolor backgrounds behind the words themselves. If you happen to be a watercolor artist, creating these will come naturally, but if not, making this type of background can seem incredibly intimidating. Ready for the good news? There's a quick and easy way to create this effect that doesn't involve any paint at all! Seriously. All you need are a few basic supplies, including a plastic bag, and you'll be amazed at what you can do.

start
WHERE YOU ARE
USE
WHAT YOU HAVE
do
WHAT YOU CAN

- Arthur Ashe

USE WHAT YOU'VE GOT

There's nothing quite like remembering someone's birthday at the last minute. I can't be too specific here, because chances are this book is going to make it into the hands of that sweet, momentarily overlooked person. But rest assured, I certainly should have had her birthday on the calendar and bought a present in advance. I was in a sticky situation and there was only one thing to do: raid the craft stash and see what I could create using only what I had on hand. Fortunately, I always have metal stamping blanks, so I chose one and quickly stamped a personal message on it. Then, I cut a length of chain, attached a clasp and put it all together to create a pretty necklace. The birthday girl loved it, and in the end, making good use of what I had available led to giving something more meaningful than whatever I'd have bought. Sometimes all we really need to do is learn to use what we've got, like our abilities and resources. Sometimes we think we need different or better skills to really make a difference, or that we could do so much more if only we had more money. But the truth is, if we find creative and meaningful ways to use the things we do have, we can do far more than we think.

Speaking of using what you have on hand, I bet you already have everything you need for today's watercolor effects tutorial. Check it out . . .

119

WATERCOLOR WORKSHOP

We're going to make a gorgeous and colorful background for our quote using a technique you're going to love. Seriously, you're going to want to do this on everything!

Let's take a moment to gather the materials you need for this workshop. You'll want a few Tombow Dual Brush Pens, an aqua brush or spray bottle filled with clean water and a small plastic sandwich bag. As you choose your colors, you'll want to stay within the same color family or even choose various shades of the same color because the inks will be mixing together. Watercolor paper is the best surface for this technique, but sketch paper and canvas can work, too.

STEP 1

Color directly onto the plastic bag using the brush tip of one of your markers.

Make several random scribbles in different areas of the bag's surface.

STEP 2

Repeat the first step using your other markers.

Don't worry about covering the entire bag with color, that's not necessary. It's totally fine to see areas of the bag that are still clear. The image below is similar to what my bag typically looks like.

STEP 3

Add water directly to your paper.

If you have an aqua brush, you can simply run it over the paper to get it damp. If not, a few squirts from a spray bottle will do the trick too.

STEP 4

Flip your bag so that the colored side is facing away from you. Place it on the wet paper and gently move it around, causing the ink to transfer and blend.

Isn't it gorgeous? All that's left to do is let it dry and then do your lettering on top.

Now you have a beautiful watercolor effect without the mess or hassle of using paint! Can you believe how easy it is? Use the space below to practice, and have fun blending different colors to see which effects you can create and which combinations are your favorites! It's a good idea to write down the numbers of the brush pens you used so you can recreate the looks you like best.

For this week's design, I used a combination of blue, teal and green markers, which creates a gorgeous blend. Feel free to use any combination of your favorite colors instead. You'll create your background, then lightly sketch seven horizontal pencil lines for the lettering. "Start," "use" and "do" will be emphasized if you use brush script (page 100) for them and brush print (page 116) for the rest of the quote. I also like to credit the author of a quote when I know it, so I added a line with Arthur Ashe's name at the bottom.

MAKE YOUR MARK WITH MASKING

Recently, we learned about using negative space to create and enhance our lettered designs. Masking is a great way to make that happen! Basically, masking is the art of using materials to protect certain areas of your work from experiencing change. So, if you're painting or otherwise adding color to a piece of paper, masking prevents that change from happening to specific parts of it. By applying masking fluid to your paper before adding color, you can easily create all kinds of designs that will appear to be white (or whatever color your surface is) in contrast to the color all around it. With the right tools, this is incredibly simple to do and creates a stunning visual effect.

UNPLUGGING

One of the easiest ways to drive me crazy is to give me a piece of technology that isn't working properly. When it happens, I try everything I can think of to troubleshoot the problem, but it's usually my husband who comes along and fixes everything simply by unplugging the machine. It's amazing, isn't it, how disconnecting something can actually make it work again? Sometimes computers, printers, televisions and even people just need to disconnect and reset. Yes, friend, sometimes you and I need to unplug too. In this digital world, it's easy to find ourselves so caught up in checking the latest email that we miss what our spouse just said. We miss the soccer game in front of us because we are too busy playing a different game on our phone. Sometimes we all need to pull the plug and take time to recharge. Today, what would it look like if your whole family went electronics-free? Can you even imagine a day like that? It may not be realistic on a daily basis, but what if we tried it for 24 hours? What if we put away our tablets and missed a few emails for the sake of renewing our minds and our relationships? We just might fix some things we didn't even know were broken.

Lettering is a great way to spend some time away from a screen; let's take some time to explore this new technique together and do something hands-on!

MASKING WORKSHOP

Our design today is very simple, just the word "unplug." We're going to make it stand out by combining the watercolor background we recently learned with masking. You'll need your dual brush markers, water and a small plastic bag again, as well as masking fluid. You can purchase masking fluid in a bottle, or you can find it in a pen too, which I find much easier to control.

STEP 1

Use masking fluid to letter your design onto watercolor paper.

If you're using a masking fluid pen, this part is very simple, because you can write with it just as you would with your marker. Since it isn't a brush tip, though, you'll need to use your faux calligraphy skills. If you're using a bottle, it can be a bit trickier. Some artists like to work directly from the bottle, while others prefer to apply the fluid with a small paintbrush. If you choose to use the bottle as your applicator, be sure not to squeeze it as you write. Gravity will make the fluid come out on its own; squeezing the bottle will just produce bubbles and can also cause puddles where you don't want them. Allow the masking fluid to dry before you move on. I like to use colored masking fluid because you can easily see where you've written.

STEP 2

Paint or use the plastic-bag watercolor technique (page 119) to fill in the entire area of your design.

That may mean covering the entire page, or perhaps filling in a pre-drawn geometric shape. Either way, make sure you have covered over every spot where you placed masking fluid. Don't be afraid to paint/color right over the top of it.

STEP 3

Once everything is dry, gently remove the masking fluid.

It should easily peel off when you rub it with your finger. Because the masking fluid resists the color, the area where it was remains white, creating your design!

What do you think? It's much simpler than it looks, right? Now it's your turn to pick a word or phrase. Create whatever doodles you like using the masking fluid and experiment with the technique in the space below. Then use it to make this week's design. All you have to do is write the word "unplug" with masking fluid in your favorite font, then follow the steps in this workshop!

CREATING CONFETTI

Is there anything quite as festive as confetti? As you continue to hone your lettering skills, you'll find them particularly useful when celebrations take place. Decorating cards and making signs are just a few of the ways you'll be able to take any party to the next level. That's why it's great to have some embellishments up your sleeve that are perfect for special occasions, like confetti! Get ready to learn a simple, fun technique for creating it that anyone can master in no time.

THROW KINDNESS AROUND LIKE CONFETTI

When my friend Michelle turned sixteen, we threw a surprise party for her. Each of us had our own little bag of confetti, and as Michelle walked down the steps, we went wild shouting, "SURPRISE!" and tossing handful after handful of shiny, colored confetti in her general direction. As a teenager, it was awesome. As an adult, I look back and feel sorry for whoever had to clean it up, because confetti was literally everywhere. Since it wasn't our house, we had no reservations about sprinkling every last one of the tiny, shiny pieces. They were in our hair, all over the floor, on the gifts, on the food . . . we didn't care where they landed. When I hear someone say the phrase, "throw kindness around like confetti," that is the image I call to mind. What would the world be like if we were as eager to scatter kind words and deeds as a bunch of sixteen-year-olds with birthday confetti? What would happen if we lavished kindness anywhere and everywhere, not caring where it went? Imagine if we treated our smiles and encouraging words as things to be that freely shared. How can you throw kindness around today? Think about the people you know you'll encounter as well as those you'll run into by chance. What can you say and do to sprinkle their lives with kindness?

Now, what do you say we get sprinkling in our lettering, too, and create some colorful confetti?

CONFETTI WORKSHOP

There are several tools you can use to create a festive confetti effect! If you have them, watercolors and a paintbrush are probably the best choice for this technique. If not, an aqua pen and your Tombow Dual Brush Markers are a good second option. If all else fails, a paintbrush, spray bottle and your markers will do the trick.

The basic idea is that we're going to load a brush with ink/paint then flick it onto our paper, creating random splatters. If you are working with watercolors, wet your brush and dip it into the paint. Hold the brush over your paper horizontally in your nondominant hand with the handle pointing toward you. Take the index finger of your dominant hand and use it to gently flick the bristles of the brush upward. I typically use the thumb of my dominant hand to help steady the paintbrush as I do this. As the bristles move, the paint will release and land on the paper in a random pattern of speckles.

If you are working with an aqua pen, you can color directly on its bristles with your Tombow markers. As you flick the bristles, gently squeeze the barrel of the pen and you'll get the same effect. The final option is to color with your markers onto a slick surface like a blending palette or plastic bag. Spray the ink with water, which will cause it to form little puddles of color. Dip a paintbrush into the color and follow the original steps. The more water on your brush, the larger your "confetti" will be.

This is fun to do with one color and even better with more! Just repeat the technique until you're satisfied with the overall effect. Be sure that as you splatter, you keep other papers and important things out of the way. You may also want to cover your work surface with something protective and wear an apron to protect your clothing from any stray color.

As you practice this technique, the only thing I want you to focus on is having fun! To create the featured design, all you have to do is letter the phrase in any way you like, then add your confetti. Don't worry about straight lines this time, just let it flow and play around with some favorite fonts. I combined brush script (page 100) and brush print (page 116) with serifs (page 39), but any combination works!

GRACEFUL RIBBONS & BOWS

It's time for another new embellishment! In this workshop, we'll be learning a decorative doodle that gives the illusion of being created from ribbons or streamers. It's perfect for birthday cards and other occasions that call for a celebration. These accents pair nicely with the Whimsical Print (page 24) or the Playful Dot-Style (page 72) print alphabets, as well as the confetti we learned in the last workshop. Use them to create a border or to jazz up the corner of an art piece, and they'll instantly make it more festive.

IT DOESN'T MATTER *how well* YOU **START** WHAT MATTERS IS *how well* YOU **FINISH**

TYING UP LOOSE ENDS

I was a member of my college choir every semester except the last one, when I was both student teaching and a brand-new wife. I knew that trying to attend two rehearsals a week just wasn't realistic and told the director so at the end of the fall semester. I also attempted to return the giant score of Haydn's The Seasons that we had started learning for spring. The trouble was, she didn't want to hear it. She tried to convince me to change my mind, refused to take the music back and told me to think about it over break. So what happened? I didn't put choir on my schedule and avoided the director on campus. Haydn lived in the trunk of my car for several years, then moved into a box in the basement. (Turns out the threats about not getting your diploma if you didn't return your music were empty.) The whole situation drove me crazy because I felt like I was never able to tie up the loose ends. Isn't it frustrating when things are left unfinished? In the years since then, I've realized that to truly do something well, you also have to finish well. It doesn't matter how you run the first part of a race if you don't cross the finish line. Even if you have a great track record at work, if you just stop showing up one day, that manner of quitting will overshadow every positive thing you did. The way you choose to finish things reflects in a major way on your character. It's always worth taking the time to tie up the loose ends and finish right, even when it's not convenient or easy. In hindsight, you'll be so glad you did.

Now, let's learn how to tie things up in our designs visually with the help of these pretty embellishments.

RIBBONS & BOWS WORKSHOP

The design you'll be creating in this workshop is one of my favorites yet, because we're going to be combining so many of the skills you've been practicing! We're going to be using your brush technique (page 81) along with shadowing and highlights (page 103), color blending (page 65) and the new ribbon embellishments inside a shaped design.

RIBBONS
STEP 1

Draw a gently curving line.

STEP 2

Draw a second line that crosses the first one and moves above it, then crosses it again moving down to its original position. Connect the two lines on the ends.

That's it! Just two simple steps and you have the illusion of a piece of ribbon. Now let's try a little variation where we put a bit of a curl on one end. The steps are the same, just add the start of a spiral to your original line.

These ribbons, especially with curled ends, make excellent borders. Now let's take what you already know and combine it with two more simple steps to form a basic bow.

BOWS
STEP 1

Draw a circle. Then, draw an oval on either side.

STEP 2

Draw a new oval on top, overlapping the original one.
Start just slightly higher than the existing oval.

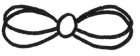

STEP 3

Draw two wavy lines coming from the center circle.
To practice, we'll take them in a downward direction, but you can also bring them out to the sides.

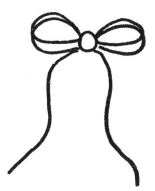

STEP 4:

Form ribbons by adding a second line that crosses the first in at least one spot.

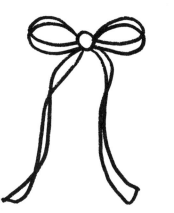

Now you have a simple bow! This type of embellishment works well at the top or bottom of a design, as well as on sketched wreaths and packages. They also look pretty in corners.

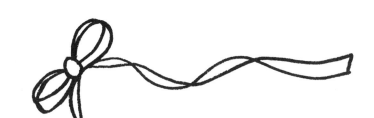

What do you think? Spend some time practicing by creating ribbons of all different widths and lengths. Try them curling, straight, and somewhere in between. Then it's time to use your new skill in creating our quote. Start by tracing something rectangular onto your paper. I used the box that holds my paper clips. Then pencil your words inside to make sure they fit. Trace over the small printed words with a black marker. Use a brush pen to go over the words in script (page 100), then write "start" and "finish" with your favorite color dual blender pens. Trace those two words in black and add shadows and highlights (page 103). Finally, draw your bow and use the blending technique to color it in any way you like. Isn't it rewarding to see all your skills working together?

ELONGATED ALPHABET

Did you know that changing one element of a letter can make it appear like an entirely different font? Artists love to play around with things like height, width and slant to create a new look for the words in a design. In this workshop, we'll be looking at the effect of stretching letters to make them extremely tall and thin. This Elongated Alphabet pairs beautifully with brush script and adds a sense of importance to your written words.

"ADULTING" ... is mostly BEING TIRED & GOOGLING how to do everything

ABOUT "ADULTING"

When I was a child, I couldn't wait to grow up. I imagined what it would be like to drive, have my own house and be in charge. When my mom served roast beef and carrots, I dreamed of the day when I'd be the cook and never have to eat that meal again. Everything about being a grown-up seemed so appealing. Until I became an actual adult, that is. The truth is, it's full of stressful decisions, bills, work and stuff I don't want to do. Sure there are some fringe benefits, like the fact that I haven't eaten roast beef and carrots once in the last 15 years, but they come at a cost, like the fact that I have to plan, shop for and cook our meals. Let's all just commiserate for a second and agree that being a grown-up is hard! It's not always fun, and there are plenty of times I'd be thrilled to hand over my responsibilities to someone else. I bet you would, too. So, what do we do? We give ourselves permission to not be perfect. Those images we have in our minds of our parents or other role models handling everything effortlessly? They're not real. If we talked to those people, they'd tell us they faced the same struggles then and still do today. We're not failing at this. Even if dinner gets burned or the bills get paid a little late, we're still doing okay. With a few good friends by our side and a good sense of humor, we're going to make it through. So, chin up, fellow grown-up. We've got this.

You've also got this lettering thing, too. Look how far you've come! Ready to take on this next challenge?

ELONGATED ALPHABET WORKSHOP

Hopefully, you'll get a laugh out of the quote we're lettering today. After all, let's not take ourselves too seriously!

The design is a very simple one, making use of just the Playful Dot-Style Alphabet (page 73) and the new Elongated Alphabet font. Basically, to create this look, we're going to take a "normal" letter and imagine that we've grabbed it from the top and bottom and pulled. How would the shape of that letter change? It would be both taller and thinner, and something would happen to things like crossbars, too. They'd be further down on the letter than they were to start.

Here's a look at what would happen to the first three letters of the alphabet if we stretched them. Both capital and lowercase letters would react in a similar way.

Any type of marker or pen will work for creating this font, but I find that the look is enhanced with a very fine tip. The thinner your lines are, the better!

Here's the entire upper and lowercase alphabet written in elongated style, as well as numerals for your reference.

ABCDEFGHIJKLMNOP
QRSTUVWXYZ
abcdefghijklmnop
qrstuvwxyz

0123456789

Now it's your turn! Practice the individual letters as well as putting them together to form words. Then, you'll be ready to write that funny quote with style! My design splits the quote into five lines, but feel free to space the words out in a different way if you get inspired. Just sketch your guides, and then start lettering, combining the Elongated and Dot-Style (page 73) alphabets to complete your masterpiece.

MASTERING MONOGRAMS

I have to confess, I'm a little bit obsessed with monograms. I love anything with my initial on it, and I definitely incorporate that into my personal style as well as my home décor. If you enjoy monograms too, you're going to love this workshop. The possibilities for how to letter a monogram are literally endless, so we won't be able to cover them all, but we'll take a look at a few basic ideas to get you started. Once you practice those, you can choose a favorite or invent your own!

MAKING YOUR MARK

Ever since the beginning of time, humans have had an intrinsic need to leave their mark. Think about it. Artists sign their masterpieces. Celebrities put their handprints in wet cement and give autographs to their fans. Even within our families, we pass down funny or inspiring stories to our children about the ancestors they never had the chance to meet. There's something inside each of us that doesn't want to be forgotten. The desire to make our mark on the world and leave a legacy is strong, and it's actually wonderful because it drives us to do and be the best we possibly can. What are the ways you want to make your own mark? Perhaps it's your artwork, or maybe something else you've built or created. Maybe it's through volunteer work in your community or through the children you've raised or mentored. Take some time today to think about the legacy you are creating as you live your daily life. How are you leaving your mark on the lives of those around you?

One of the greatest things about being creative is that you can make art that lasts forever. Let's look at one way to put your own personal stamp on things.

MONOGRAM WORKSHOP

There are so many uses for a pretty monogram! From envelopes to wall signs, monogrammed projects make gorgeous keepsakes. Create them for yourself or to give as a personalized gift; either way is a win! Today we're going to look at two of the many styles you can use to create a monogram; one is fairly basic while the other is more elaborate.

SIMPLE SCALLOP MONOGRAM

This monogram style is a mixture of traditional and modern, and there are endless variations on it. It's simple to create and fun to personalize.

STEP 1

Write your desired initial(s).

You can write in any font you like best. I tend to go with brush calligraphy (page 100) because it's my favorite and I think it looks the most elegant.

STEP 2

Draw a basic scallop shape around your letter, then go around it with a second set of scalloped lines.

STEP 3

Color in between the lines.

Here's how it looks if you stick to a black-and-white design. Another option is to use a favorite color.

To change things up a bit, rather than just coloring in the scalloped edge, fill the space with lines, polka dots or any other pattern.

For another variation, you can keep just one scalloped line and add leaves to it like a vine embellishment, or use vines on either side of the letter like parentheses.

All of these are quick and easy to sketch and look great on any personal project. Now, let's take a look at a monogram style that's a little more complex but still totally doable! This design looks gorgeous on a mug or in a frame.

LINES & LEAVES MONOGRAM

STEP 1

Write your initial, then draw a curving line with two downward loops just above it. Create another two-loop line just above the letter.

While this can certainly be done in black and white, adding color really makes the finished product pop!

STEP 3

Sketch one more set of four simple swirls, one in each "corner" of the design. Draw short accent lines under each bump in the upper and lower lines.

This is a great time to switch colors.

STEP 4

Draw a circle in each corner, in the center of your simple swirl sets. Add three small dots just above the center scallop in the upper and lower lines.

STEP 2

Draw a set of simple swirls (page 28) on the left and right of the initial.

STEP 5

Draw three lines coming out of each side set of swirls. Add leaves.

Finish by adding three tiny dots over each corner circle and one at the end of each of the longest branches. Draw accent lines under each set of swirls.

There you have it, an elegant monogram that makes use of your swirl skills too. What style do you prefer? Use the space below to practice creating monograms using your own initial. Then it's time to move on to creating our featured design. Start by lettering your initial using whichever type of monogram you choose. Then write the words "live your life, take your place, make your mark" around the outside of your shape. You'll want to do this in pencil first to make sure you get the spacing right, then go back over the words with a brush pen. Feel free to add color and embellishments to make your design even more fabulous!

BORDERS ALL AROUND

We've already learned some stylish ways to create corner embellishments and put frames around our lettering. Today, we're going to learn a new border technique that's becoming increasingly popular in the lettering world. It's simple to do but elevates your design to a whole new level. You already know how to give dimension to your letters, and this technique adds it to your entire design, making it appear to pop right off the page as one whole unit.

INTEGRITY—WHEN NO ONE IS WATCHING

I think it's safe to say that most people like to make a good impression. When others are watching, we're usually on our best behavior, and we do the things that are expected of us. But the real test of our character is what we do when absolutely no one is watching. When the cashier gives us too much change and we are the only person who notices, do we return it? If we find a wad of cash in the parking lot, do we keep it or do we turn it in, knowing that someone is surely looking for it? What about when it's easier to tell a little white lie than it is to own the truth? What do we do in those moments? Do we choose to do what is right no matter the cost? That's what it takes to truly be a person of integrity. We have to be just as committed to being honest and fair when we're alone as we would be if a thousand people had their eyes on our next move. Who are some people in your life who live this way? How have you seen them live out their integrity, and how have their examples affected you?

Are you ready to create a reminder for yourself that doing the right thing is always best, even when it costs the most?

BORDER WORKSHOP

This workshop is all about adding extra emphasis to our composition by giving it a border that draws attention to the lettered design. You'll find that unlike other borders, which can sometimes call attention to themselves, this one will pull the viewer's eye right to the lettered quote. Take a look.

STEP 1

Write your word/design.
This technique works with just about any style of lettering you want to use.

STEP 2

Trace around the outside shape, following all the bumps and lines.
Try to keep a consistent amount of white space between the letters and your trace line.

STEP 3

Add shadowing to the shape you created.
A gray or black marker will do the trick nicely.

STEP 4

Add embellishments.
Feel free to do any last-minute touches like highlights, accents, etc. to give your design a little extra pizzazz.

You'll find that the more ups and downs your design has, the more interesting it looks when you add this decorative border. If you keep your letters lined up and similar in size, the overall effect isn't nearly as visually appealing.

Ready to do some practicing of your own? Try a variety of different words and phrases, as well as several of your favorite font styles to see what effect this border technique creates. Then, go ahead and letter the featured quote on the next page. I chose to use a design that features two lines of text with some of the text within the line doubling up on itself. To do this, sketch two horizontal guidelines, then letter the word "do" in brush script (page 100) on the top one. Next to it, print the word "is" on the line, then print "what" right above it. Finish the line by brush lettering the word "right." Repeat that same pattern for the second line of text. Add some simple highlights (page 103) to "right" and "easy" to emphasize them. Finally, I added a border just like the one we talked about in today's workshop. Now you've got a fun, dimensional piece of art!

THE TRICK TO OVERLAPPING & LAYERING

If you look around right now, you'll notice that many of the things you see are overlapping one other. Perhaps you're wearing a few layers of clothing. Maybe some of the pillows on the couch are on top of others. It's only natural that as we create hand-lettered works of art, some of our letters and embellishments will be layered, too. The trick, though, is knowing how to overlap them in an aesthetically pleasing way that looks intentional and effortless at the same time.

LAUNDRY AND OTHER UNENDING THINGS

I absolutely despise doing laundry. Not because of the task itself, but because it's never finished! There's literally a constant supply of dirty clothes, socks, sheets and towels in my house and I'm willing to bet it's the same way in yours. Dirty dishes are no better. If you've ever looked at your dishwasher or washing machine and felt defeated, you're not alone. Like it or not, though, these endless tasks are part of life . . . and they aren't as mundane as you think. As a matter of fact, it's as you're doing these repetitive daily tasks that you're showing consistent love to your family and even making memories. I remember standing next to my mother every night at the kitchen sink, talking with her about my day as she washed dishes and I dried. I told her about what had happened in school and confided in her about the boys I liked. It was a time for sharing and connecting, and although I can't recall any one conversation, the feeling of trust and love we shared there remains to this day. I hope it's the same for my son. I hope one day he'll look back and remember how we used to chat about his day while folding the laundry, or how we laughed about the cat who can't seem to figure out how to escape from under an empty laundry basket. Don't be discouraged by the cycle of unending tasks— instead look for opportunities to find the magical in the mundane. I promise it's there.

Ready to make a reminder for yourself that life is so much bigger than laundry?

OVERLAPPING WORKSHOP

Today, we'll be lettering this quote about the two most unending things in your home.

The real key to making layering work in your lettered designs is to plan it very intentionally. I've seen pieces where it was obvious that an artist hadn't planned ahead, so one letter just ended up running into another. It looked like exactly what it was, a mistake. Instead, deliberately choose when and how your letters are going to intersect.

There are two main layering styles you can use to add depth and visual interest to your work. One focuses on overlapping letters within a word, while the other layers one word or phrase on top of another.

OVERLAPPING LETTERS

STEP 1

Start by writing your letters, allowing them to touch and overlap rather than leaving standard spacing in between.

I like to do this with a thick marker like the brush tip of a Tombow Dual Brush Pen. We're going to practice with the word "love" because it's nice and short, plus it's part of the quote we'll be lettering at the end of the workshop.

STEP 2

Decide which letters you want to be in the front and outline those completely.

In this particular word, I chose "o" and "e" to be the top layer.

STEP 3

Outline the remaining letters.

Let your lines stop when they intersect with the top letters you've already traced. Now you should have the appearance of multiple layers.

STEP 4

Add shadows, highlights or other embellishments.

When shadowing, I treated the word as a whole rather than trying to shadow individual letters. I decided to add some accent lines using a darker pink marker as well.

Not only is it fun to do, but also this overlapping technique makes a particular word really appear as one cohesive unit within a design.

LAYERED WORDS

Sometimes designers like to emphasize a word by repeating it in multiple fonts. To achieve this effect, first write your word in large letters. Then go back with a contrasting pen and write the same word again, this time using a small script. This technique works best if the two words look vastly different, so make sure you vary the size, color and font style.

Creating our design gives you a chance to practice the first method, as you use it to letter the words, "love" and "laundry." This particular layout has five lines of text and uses size and contrast to emphasize those two most important words. The rest of the design is done in Whimsical Print (page 24), but you can certainly substitute another favorite font.

A variation on this idea is to write a different word or phrase across the first one. For example, if I write "never fails" across my original word, I now have the complete quote, "Love never fails."

These two styles of layering in lettering produce very different results, but are both incredibly useful skills to have when planning a design. Which method do you prefer? Spend some time trying the techniques, and remember, the key is to be intentional with what you're doing.

ART DECO ALPHABET

Art Deco is a style of visual art and design developed in France prior to the first world war. It became extremely popular in the 1920s and 1930s, influencing the design of everything from furniture to cars and even ocean liners. Art Deco is characterized by geometric shapes, clear and precise lines and ornamentation. It's also associated with rich colors, luxury and glamour. So, what does that mean for hand lettering? An Art Deco font style incorporates straight lines, decorative touches and a geometric style that will make you feel like you've been transported back to the Roaring Twenties.

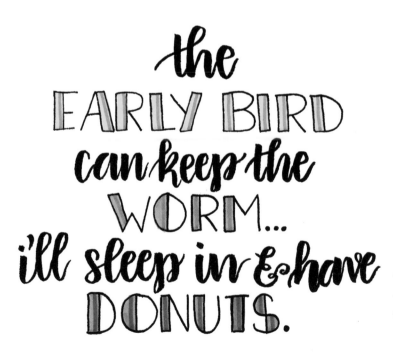

the EARLY BIRD can keep the WORM... i'll sleep in & have DONUTS.

EARLY BIRDS & DONUTS

I don't do mornings. If it were up to me, I'd sleep in until at least 9:00 a.m. every day, then slowly ease into things with a little quiet and a lot of coffee. Not one person in my family understands me. My parents are both morning people, and I married one, too. My son voluntarily wakes up before 6:30 a.m. every day. For a long time, I felt guilty for not being a morning person. After all, society tells us it's the better way to be. The early bird gets the worm, right? I felt lazy for wanting to stay in bed and guilty for wanting to slowly work my way into the day. But over time, I realized it's not a matter of right and wrong, or even better and worse. It's just who we are! Yes, it can be great to be a morning person (or so I'm told). You start the day on the right foot and can get a lot accomplished before lunchtime. If you're an early bird, good for you! Know what, though? It can be great to be a night owl, too. Nighttime is when I feel most creative and energized, and I accomplish some pretty awesome things. If you're a night owl like me, good for you! Instead of wishing we were like others or that others were more like us, we should celebrate the good things about being exactly the way we are. Early birds, go get those worms, you earned them! And night owls? Get your beauty rest. The worms might all be gone, but hey, there's always donuts.

I hope that you are able to do the exercises in this book at whatever time of day you feel most energized. Find a time and a spot where your creativity is at its best . . . then let's get to work.

ART DECO WORKSHOP

Incorporating the Art Deco style into our design is going to be tons of fun, especially since the quote itself is sure to make you smile.

Let's take a look at how to take the important elements of this style and turn them into a font. Art Deco is big and bold, so our letters should be, too.

STEP 1

Start by writing the letters in a normal print.

STEP 2

Make it bold by adding a double line on one side of the letter.

This is similar to the first step of the Whimsical Print Alphabet (page 24). This time, though, we're going to place the second line a little further out so that we have a larger open space to work with. We're also going to make straight lines whenever possible, so on letters like "C," "O" and "Q" we'll draw the second line straight down through the letter rather than mirroring the letter's natural curve.

STEP 3

Fill in the open spaces with the brush tip of a dual brush pen.

Remember, Art Deco is associated with rich colors. I went with jewel tones, but any colors will work as long as one is darker than the other.

STEP 4

To incorporate both precise lines and ornamentation, use the fine tip of a darker Dual Brush Pen to draw a vertical line through the colored area.

Isn't this a great look? If you don't happen to have colored markers on hand or your project lends itself to black and white, you can create a similar effect by filling in all but a thin stripe of the area with your black pen.

ABCDEFGHI
JKLMNOPQ
RSTUVWXYZ
abcdefghijk
lmnopqrstuv
wxyz
0123456789

Here is a look at the entire alphabet, as well as numerals. Take some time to practice forming the shapes and writing a few words to get a feel for the style. Then go ahead and create your finished design! It's a combination of Art Deco and brush lettering (page 100). As usual, start by sketching your guidelines (you'll need six this time) and the positioning of your words. Trace your words with marker, then play around with several color combinations for filling in your Art Deco lettering to make those words really stand out.

EMBELLISHED DROP CAPS

Drop caps, otherwise known as initial letters, are large capital letters found at the beginning of a paragraph or text block. They are at least the height of two lines of text and are both decorative and functional. The history of drop caps goes all the way back to the 4th century when scribes used them to distinguish where a new section of text began. Because the earliest books did not often have paragraph or sentence breaks, readers depended on these markings to help them find their place and to signal when a new idea was beginning. Eventually, as standard spacing developed, drop caps became less necessary, but were still used for decoration. Printers would leave space in and around the text of a book so that owners could hire skilled artisans to create beautiful illuminated letters in those spots. Sometimes the illustrations actually helped those who couldn't read to understand what the text was about. Today, drop caps can still be used as a decorative embellishment and a nod to a rich history of art and the written word.

HISTORY REPEATS ITSELF

Although I don't have much of a memory for historical dates and names, one thing I know for sure is that history tends to repeat itself. In fact, to prove it, all you need to do is look at current fashions. What goes around comes around, and my son has slap bracelets that prove it. The things I was wearing in the '80s are coming back into vogue (though only heaven knows why) thirty years later. The same is true when it comes to the behaviors of groups of people. Racism, terrorism and any other "ism" you can think of have manifested themselves all over the globe in every time period under the sun. Within families we see it too. The habits and beliefs of parents are taught to their children and many times a struggle repeats itself for generations. So what do we do with that? The only thing we can hope to do is learn from the past and try not repeat its mistakes. The trouble with knowing that history repeats itself is that we can accept it as inevitable and use it as an excuse when we do the same things over and over. It's up to each one of us individually to break that cycle. When we make a mistake, will we take to heart what we experienced and make a conscious effort to not let it happen again? Will we teach our children and encourage our friends to do the same?

Today, as we reflect on our own role in the repetition of history, let's explore one of history's oldest forms of lettering!

155

DROP CAPS WORKSHOP

The "H" in "history" is going to be our focus as we letter the quote "History repeats itself."

The best thing about creating drop caps is that there's no right or wrong way to do it! As long as the letter is a capital and it's large and in charge, you've mastered it. To give you some creative inspiration, though, here are some styles you might want to try.

SERIF PRINT

Since drop caps are associated with history and tradition, an initial in a bold serif font (page 37) always looks appropriate. You can decorate it with floral vines, outline it, color it in or simply let it stand alone. For this example, I wrote my letter in purple brush pen, outlined it in black, then added the vine for a pretty, decorative touch.

BRUSH SCRIPT

If you're going for an elegant look, you might want to write your initial using the brush lettering technique (page 100). While no further embellishment is necessary, you can always add shadows and highlights (page 103), extra swirls (page 28) or any other decoration that fits with the style of your piece.

MODERN

For a more modern twist on a classic style, print your sans serif letter in a bright color. Try color blocking and/or funky patterns to make it feel current. Geometric shapes and unexpected touches bring this tradition into the 21st century.

BOXED IN

Many traditional drop caps were enclosed in a decorative box filled with a pattern. Draw your letter in black and place it inside a square. Then use a fine-tip pen to create swirls or vines that fill up the entire space. This style feels antique and reflects the rich history of initial letters.

These are just a few of the many styles of drop caps you can create. The only limit is your imagination! On the next page is a full alphabet to give you more ideas. Don't feel as though you need to copy these letters when using them yourself; instead use them as a springboard for creating all kinds of initials in your own work.

Pick a few favorite letters and experiment with drawing them in a variety of styles. Choose the one you like best, and use it in creating the featured design. Just because I used a script "H" with a floral vine doesn't mean you have to do the same. Create any kind of drop cap you want, as long as you promise to have fun doing it. Then, fill in the rest of the quote next to it in smaller letters. I used a very simple uppercase print because I didn't want to distract from the drop cap itself.

ON THE ENVELOPE: LETTERING ADDRESSES

One of the most common ways to use hand lettering is to address an envelope. Whether it's a wedding invitation or just a note to say hello, any piece of mail addressed by hand is exciting to receive. Today, we will look at a few tips and tricks for creating a beautifully lettered envelope. We'll talk about placement, spacing, design and more, so that you're prepared to address anything in style.

dan latta

1014 LA PLAYA CIRCLE
MYRTLE BEACH,
south carolina
8·0·0·0·3

PUT IT IN WRITING

Imagine that I put five pieces of paper in front of you. Each has the same message on it, handwritten by a different person. Four of the people are strangers, and one is someone you know well . . . perhaps a parent, a spouse or a best friend. Now imagine that I asked you to identify which slip of paper was written by the person who is close to you. You'd have no trouble, would you? Although each of us learns the same alphabet, our individual handwriting is unique and recognizable. Even in hand lettering and art, we put our own flair on the way we form and connect letters, making it uniquely our own. That's part of the beauty; our writing is a piece of us. It's why we save handwritten letters and cards for years. It's why people get custom-made jewelry or tattoos of words written in a loved one's script. Our writing, not just our words, means something to others. It has value. As you become more comfortable with your hand lettering, don't be afraid to let yourself show through it. Don't get upset when your lettering doesn't exactly replicate someone else's. Instead, celebrate that it has your own flair and is therefore that much more of a treasure.

One of the most exciting handwritten things to receive is a piece of "snail mail." Let's take a look at how to make it beautiful, starting from the outside with the envelope itself, shall we?

LETTERING ADDRESSES WORKSHOP

As we practice lettering on envelopes, this time each of us will have a slightly different design, because I want you to use your own address or the address of someone you know.

I'd say there's no wrong way to address an envelope, but that's not exactly true. While a pretty hand-lettered envelope can be a piece of art, let's not forget that its ultimate function is as a piece of mail. We can certainly take some artistic liberties in how we choose to write the information, but at the end of the day, it has to be easy for the post office to sort and deliver to the right place. Here are a few basic tips to keep in mind.

GET FANCY WITH THE NAME.

For the most part, as long as the address is correct, a piece of mail will be delivered to its destination no matter what the name might say. I get plenty of flyers addressed to "Resident" and the occasional one for "Amy Latte." Neither of those are my given name, but they come to my mailbox all the same. You can flourish and decorate the name all you like, and if you'd rather write "Grandma" than "Barbara," so be it. I personally like to use my fanciest brush lettering (page 100) for this part, but any font you like is fair game. Add a banner (page 16) or add some flowers (page 40) if you're so inspired; this is the place to play around a bit.

amy latta

STAY SIMPLE WITH THE ADDRESS.

Make sure that you follow whatever protocol your country or region has for writing an address and that your lettering is totally legible. I like to use a print font for this part so that it's straightforward and easy for the postal service to deliver. It's best to keep this part free from extra embellishments.

1214 PALM DR
ORLANDO, FL

MILK THE ZIP CODE.

The zip code is one of the most important pieces of an address, and it can be one of the most decorative too! Instead of just cramming it after the state abbreviation, give it a line of its own. Stretch it out and make it a focal point. As long as the mail carrier can easily read it, do whatever you like.

1·7·3·3·1

17331

— 17331 —

1·7·3·3·1 →

OTHER TIPS & TRICKS

As with any of our lettering, you'll want to sketch some light pencil lines on the envelope to keep your address straight and evenly spaced. There are actually tools you can buy to help space the lines for you, like the Lettermate.

Metallic or white pen on a dark envelope is a gorgeous effect, and color can instantly make a white envelope more festive.

Here are some ideas for ways to decorate the front of an envelope; feel free to use the parts you like and change the ones you don't. Play around with lots of different layouts in the provided practice space. After all, not every occasion is the same. Chances are, you wouldn't address a birthday invitation and a wedding invitation in an identical style.

For the featured look this week, use the provided envelope illustration as your canvas and create any type of lettered address design you like. Use your own information or the address of someone you know and turn it into an artistic masterpiece!

erin kerst
10904 VIRGINIA AVE.
MYRTLE BEACH, SC
— 8·0·0·1 —

lisa kemper
822 Mariposa Way
Hanover, Maryland
21075

PLAYFUL PATTERN FILL

Patterns of all kinds are visually appealing. That's why if you look around your home, you'll probably see plenty of them. Rugs, curtains, pillows, chair cushions, throws and more are often decorated with patterns because they brighten up our homes and add interest to an otherwise functional object. Geometric shapes, lines and florals are popular pattern types in home décor, but they're also excellent for adding some pizzazz to our hand lettering. Filling in shapes or letters with a playful pattern can add a touch of whimsy while making our design even more interesting.

FILLING YOUR DAYS

As we go about our daily lives, it's easy to slip into a comfortable routine. Here in the Artsy House, my routine starts when hubby goes to work, then I get Little Crafter off to the bus stop for school, start my own work with the blog and Etsy shop, as well as household duties, make dinner and before I know it, we're into the bedtime routine. A week can go by and when I look back, it's a blur of the same things over and over. When I start to feel that way, it's a good reminder to take a step back and make sure I'm remembering to really live, not just go through the motions. What does that mean? For me, it's being intentional about putting my heart into what I'm doing. It means purposely choosing to play and make memories with my son. It means only choosing to work on things that line up with my brand and my passions. It means taking time to do something just for myself because I love it. None of us can escape our daily routines and responsibilities, but we can infuse them with meaning. We can put our hearts into the things that matter and concentrate on the people we love. When we do, we'll be living more fully and filling our days with life and love. I don't know about you, but that's how I would rather live.

Just as we strive to fill our schedules with meaning, we can fill our letters and drawings to enhance them, too. Are you ready to give it a try?

PATTERN FILL WORKSHOP

In this workshop, our lettered phrase is going to be the reminder, "Don't fill your life with days, fill your days with life." We'll be making use of Pattern Fill as well as practicing brush technique (page 100) and flourishes (page 68) in a shaped design.

Believe it or not, you've already done Pattern Fill as you've completed some of the other designs in this book! Any time you're taking a space and filling it in with something other than just plain color, you are using this technique. Pattern Fill is exactly what it sounds like, filling an area of your design with a pattern. You can use it to fill in shapes and doodles or even your letters themselves. Let's take a look at how it applies to the alphabet, then you'll be ready to use it anywhere!

STEP 1

Draw a letter that includes some blank space.

The Whimsical Print font (page 24) works well for this; just draw your double line and don't color it in!

STEP 2

Fill in the blank area with the pattern of your choice.

Easy, right? The hardest part is choosing what pattern to use! Stripes are one option; you can draw them horizontally, vertically or diagonally and vary the widths. Polka dots work well and so do checkered boxes.

For your reference, here is a Pattern Fill sample alphabet to give you ideas of the many types of patterns you can create. Each letter is different, so there are 26 options to get you started. There's no wrong way to do this technique, it's up to you to choose a pattern that works well for your design.

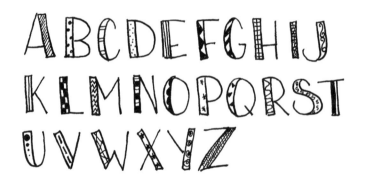

Spend some time practicing a few of the different patterns that appeal to you the most. Try using the same pattern for a whole word to see the effect it creates.

To create the "fill your days" design, start by tracing a round object like a small bowl with a pencil to create a circle on your paper. Then, gently pencil in the spacing of your words. The words "life" and "days" are what we want to stand out, so we're going to write those in Pattern Fill, while the rest of the phrase is brush calligraphy (page 100). Once you have your words positioned, add a few flourishes (page 68) to complete the circle shape. Trace over the design with your markers and fill in "life" and "days" with the patterns of your choice!

FANCIFUL FEATHERS

Feathers are so popular in home décor and fashion right now that it only makes sense to include them in our lettering, too. They give off a fabulous boho vibe and work wonderfully to accent quotes about nature, imagination and flight. Feathers also add a touch of whimsy, so they're perfect for pieces designed for kids. As with most of our other embellishments, there are tons of variations on how to draw a feather, beginning with a simple shape and becoming more detailed and complex. Today we'll look at two quick and easy doodles that will look spectacular accenting your lettered art.

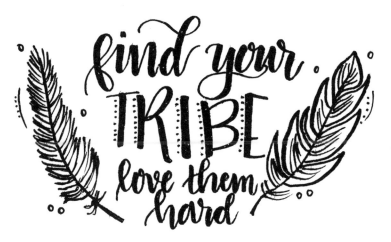

FIND YOUR TRIBE

One of the best feelings in the world is being truly understood. Sometimes, it can be hard for creative people to feel like we fit into a logical, tech-based society. That's why I'll never forget the feeling I got the first time I went to the Craft & Hobby Association Mega Show. There were hundreds of people in one place who were just like me! Makers. Creators. Entrepreneurs. I felt like I could walk up to anyone and chat with them as though we'd been friends for years. I get the same feeling every time I meet a fellow craft blogger in person. There are certain things about each of us that can only be understood by others who have the same passions and traits. Those people, the ones who inherently "get" us? They're our tribe. We may live on opposite sides of the globe, but we're made of the same stuff. One of the best things you can do for yourself both personally and professionally is to find your tribe. Connect with them. Choose a few people you trust, then encourage and support them and let them do the same for you. These are the people who can give you the best advice, point you in the right direction and understand what's in your heart. Seek them out and when you find them, don't let them go.

As you think about who those folks might be in your life, we're going to letter a reminder of how important they really are. Let's get started!

FEATHERS WORKSHOP

Today, we're going to combine brush script (page 100), brush print (page 116) and feathers to create a design that emphasizes the significance of having a group of people who really understand you.

LOTS OF LINES FEATHER

STEP 1

Draw a slightly curving line.
This will be the stem. Make it however long you want your feather to be.

STEP 2

Starting at the top of your line, use a very fine-tip pen to draw short lines coming out from the center stem.
These lines should curve slightly upward at the ends and get gradually longer as you get closer to the bottom.

Repeat until you have covered both sides of the stem with these lines and created the look of a feather.

OUTLINED SHAPE FEATHER

STEP 1

Draw a slightly curving line.
Once again, this creates the center stem.

STEP 2

Draw a shape similar to a leaf at the top of the line.
Let it come down slightly farther on one side than the other instead of being perfectly even.

STEP 3

Just below your shape, draw another shape on each side that is just slightly wider than the one above it and points upward.

STEP 4

Continue down the stem adding more shape sections.

You can leave it just like this and color it in, or you can continue to add more details.

STEP 5 (OPTIONAL)

Add detail lines inside your shapes and a few just below the lowest ones.

Feel free to add color or any other embellishments. Experiment with the two different types of feathers in the practice space below and plan how you'd like to incorporate them into your final design. Then, go ahead and letter your quote as a reminder to find and hold on to your tribe. This design is a combination of brush script (page 100) and brush print (page 116) framed by feathers on the left and right. Start by sketching the position of your words, then add the feather accents. I decided to use one of each style, but doing two of the same kind works just as well.

LEARNING ABOUT LIGATURES

When was the last time you used a ligature? I just recently learned what the term means, only to find that I use them all the time! Whenever you join two or more characters together in a way they wouldn't normally be combined, you've formed a ligature. For example, writing one letter inside another or merging the parts of two different letters will do the trick. Think for a second about how you would write the name, "Matt." Would you individually cross each "t," or would you make one long line that crosses both? If you chose to use one line, you'd be creating a ligature. The two individual "t's" would become one character because you merged their parts. Today we'll be learning about when, why and how to use ligatures as part of our hand-lettered designs.

LEAVE IT BETTER THAN YOU FOUND IT

The first day of each new school year at my alma mater featured an assembly during which our phys ed teacher, Mr. Powelson, would take the stage and lecture us about how to treat the school and each other. He was a compact man, but what he lacked in stature, he made up for with a commanding presence that filled the auditorium. In his unmistakable raspy voice, he'd shout, "If you see a piece of trash, PICK IT UP! DON'T YOU CARE?!" In his own way, Mr. Powelson was trying to instill a life lesson in us; wherever you are, leave it better than you found it. It doesn't matter where you are or what you're doing, that's never a bad piece of advice. Sometimes that might mean filling up your spouse's gas tank after driving his or her car. It might, as our teacher pointed out, require picking up trash or otherwise making an area cleaner. Perhaps it just means sharing a smile with someone that makes wherever they are a nicer place to be. What would happen if everywhere we went, we asked ourselves the question, "how can I make this better than I found it?" Can you imagine what that would do for others and for ourselves?

As we consider this question, we're going to put a new skill to work that will enhance the look of our designs. Ready?

LIGATURE WORKSHOP

Today's design, a reminder to leave things better than we found them, allows us to play around with creating ligatures as we letter our quote inside a circle of flowers and leaves. The phrase lends itself to our topic because it features a few specific combinations of letters that we're going to learn to draw as one image.

Ligatures originated as a form of abbreviation. Scribes would run letters together to form abbreviations for words or letter combinations so they could write long texts quickly. Over time, some of these combined characters actually became widely used symbols, the most familiar of which is the ampersand. In Latin, the letters "et" mean "and." If you look closely, you'll see how the modern ampersand we use originated from a ligature of "et."

Besides using ampersands, there are two main ways to incorporate ligatures into our hand lettering. One is by joining the components of two neighboring letters in a word. Here are a few of the most common examples. The horizontal line used to cross a "t" can easily be used as the beginning of the loop we use to form an "h" or an "l." As we mentioned earlier, it can also cross two "t"s instead of just one.

Even if the letters aren't directly next to one another, you can still merge them together, as in the word "initiate."

The second way you can put ligatures to use is by joining letters that are in separate words altogether. Using the bottom of one letter to form the top of another that's below it is a common way to work this technique into a design. Not only does it look fancy, it adds cohesiveness and unity to your piece of art. Notice how the embellished tail of the "r" becomes the cross piece for both the "h" and the "e" below it. This is a beautiful way to tie together the words of a phrase, and it still works even when you're using different fonts!

Spend some time repeating the connections that form those common ligatures like "th," "tl" and "tt," because you'll be able to use them in many of the pieces you letter. In our featured design alone, there are four ligatures! To create the design, you'll start by tracing a circle in pencil and positioning your words. Use the brush lettering technique (page 100) and your brand-new ligatures to fill in the phrase, then finish up by adding a wreath (page 12) and some colorful flowers (page 40) for a decorative touch.

P.S. Remember, there's no one you have to please with this design but yourself! So, relax and enjoy creating something beautiful.

LEAPING INTO LEAVES

Elements from nature are always useful, pretty embellishments in a hand-lettered design. We've already experimented with vines, laurels and flowers and incorporated them to add color and interest to some of our work. Today we're going to add another piece of nature to the repertoire: leaves. Yes, we've drawn some simple leaves to go along with our floral sketches, but now we're going to focus on different shapes and leaf types. These are perfect to play with in the fall, particularly when you color them in, and they make great accents for everything from Thanksgiving place cards to autumn-themed framed art.

LIFE'S SEASONS

Every now and then I find myself in a situation where I look around the room for an "adult" to handle things, only to realize that I'm the oldest one present. It's funny how in my mind, I'm still about 21, but my body disagrees! While my twenties were a time of self-discovery, this current season of life is much more focused on someone else: my son. It's about self-sacrifice and unconditional love. It's about making hard decisions and paying bills . . . everything I associate with my own parents instead of myself, because it's what I watched them do for twenty years. As for them, they're in a new season of life, too, acting as caretakers of their own parents. Just as there are seasons of the calendar year, our lives are marked by seasons as the years go by. It's up to us to figure out how to enjoy and make the most of each season as it comes. What can we learn from the one we're in right now?

Changing leaves are a visible sign of the passage of time, so they make a great embellishment for seasonal lettering projects. Let's take a look at how to make that happen.

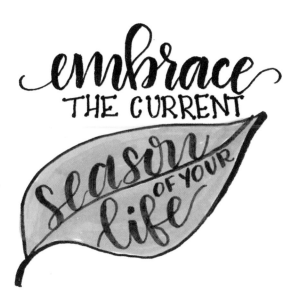

LEAVES WORKSHOP

In nature, leaves come in all shapes and sizes, so naturally there are many different ways to sketch them, too. Today we're going to look at a basic leaf shape to get you started, then talk about a few ways to create variations. Our design incorporates a leaf along with your brush style lettering (page 100) and the Dot-Style Alphabet (page 73).

STEP 1

Draw a line that curves slightly up and to the right.

The longer you make your line, the larger your leaf will be.

STEP 2

Starting about ⅓ of the way up the line, draw a basic leaf shape by curving up to a point, then back down.

STEP 3

If you like, add short lines coming from the center stem of the leaf to give the idea of veins.

You can extend these lines all the way to the outline of the leaf edge, or keep them shorter as I did in this sample.

STEP 4

Color it in!

Depending on the season you want to represent, choose from various shades of green, yellow, orange, red and even brown. Use your color-blending techniques (page 55) for a vivid, realistic effect.

That's all there is to creating a simple leaf. To create variety, play around with the shape of the leaf outline itself. Try making it long and thin and rounding the tip instead of bringing it to a point. Or, go for a shorter, more rounded shape.

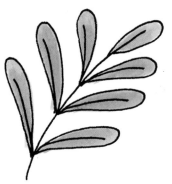
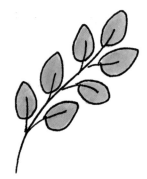

Using several styles of leaves in a floral design adds visual interest and helps distinguish different types of plants. Any way you draw them, leaves add a pretty, natural vibe to your lettering. Try some different styles in the practice space below. To create today's design, you'll be using the leaf to hold some of your lettering. You'll want to start by lettering the first part of the phrase, then drawing your leaf below. Fill the leaf in with color, then letter on top of it to finish up!

TALKING ABOUT TREES

Seasonal embellishments are a great way to turn your everyday lettering into something timely. We've already learned about adding leaves to autumn-themed projects; now it's time to talk about trees! Whether they're colorful, lacking leaves or evergreens, sketched trees give the feeling of a particular time of year. Evergreens in particular are a perfect choice for decorating holiday items like gift tags or cards. Trees are actually quite simple to create, just a series of shapes and lines, as you'll see in this workshop!

CREATING BEAUTY

One of the most meaningful things my husband has ever said was the time he turned to me and commented, "you make my world a more beautiful place." He went on to describe how much he loves that I paint our furniture, create art for the walls and decorate for holidays. I was speechless, because it never occurred to me that those things made such a difference to anyone. It also never occurred to me to do anything other than try to make the things around me lovely. When I see an abandoned piece of furniture, my first thought is what it would look like if I "rescued" it. When I look at empty walls, I see the art I could create to fill them. Those things come naturally; they're part of who I am. Know what else? The fact that you have been taking this lettering journey tells me something about you, friend. You, too, are a maker, a creator of beauty. Even if you feel like you're not naturally skilled or inherently creative, you have a desire to make the world around you a more beautiful place. That in itself is a gift to everyone who knows you. Whether they've told you or not, they notice what you do. Never stop transforming the things around you, even when you feel like it doesn't matter, because creating beauty always makes a difference.

As artists, it's also important to continually develop our skills, learning new techniques so that we can create in ways we never imagined. Are you ready for your next embellishment lesson?

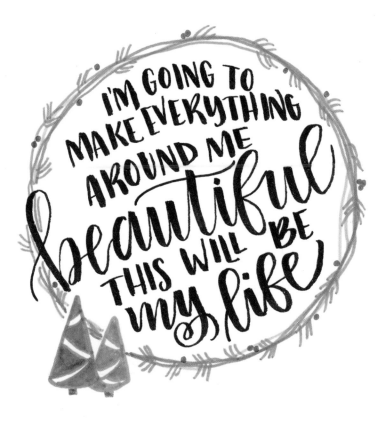

I'M GOING TO MAKE EVERYTHING AROUND ME beautiful THIS WILL BE my life

TREES WORKSHOP

I don't know about you, friend, but I have never resonated more with a quote than I do with this one, spoken by interior designer Elsie de Wolfe. To bring it to life, we'll be combining familiar techniques like shaped designs (page 77), brush calligraphy (page 100) and vines (page 12), as well as adding some new trees to the mix.

Just as there are many varieties of trees in nature, there are countless ways to draw them in your lettered designs. Today we're going to look at two basic types of trees to get you started.

EVERGREENS

Especially around the holidays, these trees will come in handy for decorating just about any project. If you want a fun, modern look, here is the easiest way to draw one.

Simply sketch a triangle for the body of your tree. Then, add a small square or rectangle to the bottom for a trunk. The fun part comes in as you add details and color to these basic shapes.

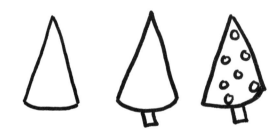

Fill in your tree shape with any pattern you like, including polka dots, stripes or stars, then add some color to make it really festive.

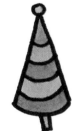

These little evergreens are cute enough by themselves, or you can group a bunch of them together for a great holiday effect!

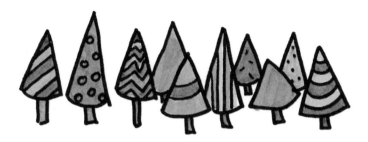

Another technique for coloring them in involves the negative design idea we learned (page 107). Sketch your triangle as well as a basic design. Here I drew curving lines to resemble a garland. Then color in everything but the design, leaving that part white.

If you want to create evergreen trees that look slightly more realistic and less geometric, here's another technique to try. Start by forming a triangular shape made from bumpy lines. Don't worry about making the bumps all the same size, you actually want some variation to make it look more "tree-like."

Next, add a few short bumpy lines inside the tree shape as well. Draw a rectangle trunk at the bottom of the shape.

All that's left is to color it in and you've got yourself an evergreen tree!

DECIDUOUS TREES

This type of tree starts with a circle or oval shape made from the same kind of bumpy lines you were just creating.

The next step is to add a trunk and branches. The simplest way to do this is to think of the branches as "y" shapes, then extend them so they connect.

When you draw them inside the shape you created, here's what you'll have.

Adding color helps show the season; a pretty pink or purple is great for spring blooms, green is perfect for summer, or fall colors show the changing leaves. Don't forget about using your blending techniques as you color. To create a winter tree, simply skip the first step and just draw the branches and trunk for that stark leafless look.

In the space below, take some time to have fun sketching the various types of trees. Which ones do you enjoy the most? When you're ready to move on to the feature design, you'll want to start by using a pencil to trace a circle onto your page. Inside the circle, roughly sketch the positioning for your words. Once they all fit, starting with the word "beautiful," trace over them with your brush pen. With the thin end of green dual brush markers, trace around your original circle, allowing the lines to overlap and create the effect of multiple vines. Draw some short lines to represent pine needles at random spots around the circle, as well as some red berries. Finally, draw in your trees and enjoy your finished piece of festive art. If it doesn't happen to be winter where you live right now, feel free to substitute for other seasonal embellishments. Just replace the pine needles with leaves and the berries with tiny flowers. Use whatever trees best fit with the rest of your design.

EMBOSS ALL THE THINGS

I have always loved things that sparkle. It's not at all uncommon to find glitter being used somewhere in our house, so it's no surprise that one of my favorite things to do with a lettered piece is emboss it! Embossing is a technique that involves creating a raised design that stands out in relief. There are many ways to emboss, but the specific kind we're going to focus on is heat-embossing. Heat-embossing involves creating a design using an adhesive ink, which then gets covered in a special powder. When the powder is heated, it melts, forming a smooth raised design wherever the ink was placed. Depending on the powder used, the design may be shiny, metallic or even glittered.

BUT FIRST, COFFEE

As you now know, I am about as far as you can get from being a morning person. But despite how I feel about mornings, I've learned that the way I start my day has a direct effect on how the rest of the day goes. Have you noticed that, too? If I don't begin on the right foot, it takes an awful lot of effort to turn the day around. That's why I think it's so important for each of us to identify our "first thing." Your "first thing" is an action you make sure to do at the beginning of your day that gets you in the right frame of mind. It's what focuses you, motivates you and gets you going. It might be a single action, or it could be a routine involving several different parts. For my hubby, it's a shower and some quiet time. You know mine involves coffee! My mom likes to read in a devotional book, and my son likes to work on his world in Minecraft. Some folks, although I may not understand them, choose exercise. Whatever we choose, it's worth making time for something each day that puts us in the right frame of mind. The rest of our day depends on it!

Take a minute to think about what it is that helps you start off the day right. Do you do it regularly or only occasionally? We're going to letter about it in this workshop.

EMBOSSING WORKSHOP

As you create today's design, feel free to use whatever word or phrase best represents your own "first thing." We'll be combining an advanced banner (page 45), brush print (page 116) and faux calligraphy (page 8) with our new embossing skills.

Most of our hand lettering techniques only require a few basic supplies, like paper and our pens. Embossing, on the other hand, can't be done without a few special tools. For this technique, you will need an embossing pen, embossing powder and a heat tool. Let's talk briefly about each one. The embossing pen writes with a special type of ink that is extremely sticky and dries slowly. More often than not, clear is the best way to go, but some folks prefer black so they can easily see where they've written. Embossing powder is what will actually melt and be the visible part of your design. It is available in a huge variety of colors and finishes, including all kinds of sparkly metallics. Finally, the heat tool is designed specifically to melt the powder to a smooth finish without causing any damage to your surface. Although it may seem like a job your hair dryer could do, trust me, you want the right tool. Hair dryers don't concentrate the air in the same way, so your powder will blow everywhere. If this is a technique you really want to do, it's worth making the investment to get what you need.

Once you have your basic tools, it's time to get started!

STEP 1

Use the embossing pen to write your word or phrase.

Because these are not brush tip, you will need to use faux calligraphy to create the brush-lettered look.

STEP 2

Immediately sprinkle embossing powder over what you just wrote.

In this case, less is not more. Sprinkle the powder generously over the entire area to ensure that every last bit of the ink is well-covered.

STEP 3

Remove excess powder.

I find that the best way to do this is to turn my surface sideways onto a piece of scrap paper or card stock and tap gently. All the extra powder will fall to the scrap paper, leaving only your written design covered. Use your scrap paper to form a funnel and place the extra powder back in its container so you can use it next time.

STEP 4

Heat your design.

Hold the heat tool several inches from your lettering and watch carefully for signs of melting. It usually only takes a few seconds and you will clearly see the powder change. Once it is melted, there's no need to heat that area any longer. Move the tool to another part of your design until the entire thing has taken on the melted look.

185

That's all there is to it! Embossing is an easy way to add all kinds of sparkle to your lettered projects, including journals, place cards, wooden signs and more. Ready to give it a go? Choose what word or phrase is going to be your "first thing," then follow the steps to letter and emboss it. Finally, go back and add your banner (page 45) and the words "but first" over the top. Take some time to sketch out your design and practice a bit, then make yourself a masterpiece!

RELAXING WITH ZEN DOODLING

In a book about lettering for relaxation, I would be remiss if I didn't touch on the concept of zen doodling. Essentially, zen doodling is the art of creating designs using a random combination of patterns divided by solid lines. But it's about far more than the finished product. The emphasis is really on creating the doodle in a way that relaxes your mind and body. Zen doodles aren't meant to be meticulously preplanned, but rather spontaneously drawn as a form of artistic expression. Incorporating this idea into your lettered projects can help to make hand lettering even more of a relaxing, stress-reducing hobby.

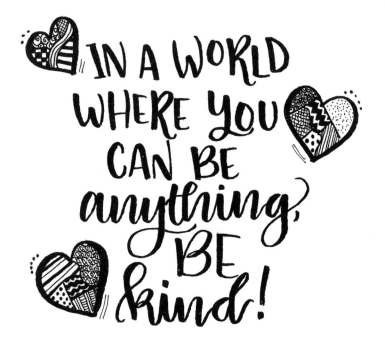

KINDNESS IS FREE

My dad has always said that nothing in life is ever really free. For the most part, he's right. Most "free" offers promise something great, but there's a catch. When you read the fine print, it turns out that there's something you have to do or pay after all in order to get what you wanted. Despite the advertising, there's actually a cost. There's one important exception, though. It costs us nothing to be kind. Each day, we encounter others wherever we go. We see our families, our friends, our co-workers and plenty of strangers as we go about our business. And each time we have an interaction, we have a choice to make. Will we show kindness? Will we smile and say hello to the person we don't know or act as if she doesn't matter? Will we laugh with the waiter who dropped our plate or will we make a fuss about it? In every situation, we can choose kindness and it won't cost us a thing. In fact, the world will be a little bit richer for it.

As you get ready to dive into your zen doodling process, let your mind focus on ways you can show and receive kindness to those in your life.

ZEN DOODLING WORKSHOP

Choosing kindness is one of the ways you and I can literally change the world, starting in our own families and neighborhoods. We're going to letter that reminder in a combination of brush calligraphy (page 100) and brush print (page 116), then embellish it with some hearts featuring zen doodling.

STEP 1

Draw a basic outline or shape. If it's not already divided into small parts, divide it using thick, solid lines.

For practice, we're going to use a shape that lends itself really well to this kind of art, a feather (page 167).

STEP 2:

Fill in each small section with a different pattern.

Here are some sample patterns to get you started. There are lots more you can use too; as long as it's a pattern you can repeat, you can use it. The finer your pen tip is, the more detailed and crisp your doodle will be.

That's all there is to it! The fun is in filling in the patterns and letting yourself get lost in the repetition of creating them. It also makes a really interesting visual effect, don't you think? Typically, zen doodles are black and white, but you can always feel free to color them in. For our purposes, you can use zen doodle for embellishments, like the feather, borders or even letters themselves. Here's a look at my name written using this technique.

As you practice creating your own doodles, the one thing you have to promise is that you won't get caught up in planning and perfection. Just relax and let your mind wander as you fill in the various sections of your designs. Relaxation is the name of this game. Don't worry about keeping the lines perfectly straight in our featured quote this time either, just let your letters bounce around a bit. Write the words using brush print or any other font, then draw a few hearts around the quote that you can fill in with this zen doodle style.

SLANTED–LINE SHADOWING

By now, I hope that incorporating shadows and highlights into your work is something you regularly do to create dimension. We're going to look at a new way to create shadows in this workshop. Rather than the fluid lines we typically use, we're going to take a different approach and use lots of short, straight lines to create the illusion instead.

IMAGINATION AND WINGS

Why is it that children are encouraged to use their imaginations at all times, but we receive the opposite message as adults? Just this morning, our two-year-old neighbor was walking around roaring in the most adorable fuzzy green monster slippers, and I thought to myself, "How much fun would it be to have a pair of those that fit me?" Why is it that at two, we imagine we can be anything we want to be, but at 32 we're supposed to just settle into our existing lives? Imagination is a precious thing and it's only when we allow ourselves to use it that we do great things. What would have happened if Edison hadn't imagined the lightbulb? It may have sounded crazy at the time, but someone once imagined all the computers in the world connected to one another and able to communicate, leading to the creation of the Internet. If we don't imagine something, we can't achieve it. When's the last time you let your imagination run wild? What kinds of things do you like to pretend or dream? The world is a better place when we allow ourselves to be creative and imagine what could be, so why not start today?

Ready to jump in to our final embellishment workshop? Grab your imagination and let's go!

SLANTED-LINE SHADOWING WORKSHOP

This inspiring quote by Muhammed Ali is a beautiful way to remind ourselves of the power of imagination. We'll be putting our 3D Bold Font (page 50) skills to use, along with a banner (page 16) and some brand-new shadowing.

The only skill you need to create successful slanted-line shadowing is to draw lots of tiny slanted lines next to one another. You already did this when you learned to do Pattern Fill (page 163) as well as in your zen doodling (page 163), so it should be a piece of cake now.

First draw your letter. We'll start by looking at an "a" written in brush calligraphy (page 100). Then think about where your shadows would fall. Anywhere you would normally place a gray brushstroke should get filled in with short slanted-lines instead. See? Easy as pie! Actually, I tried baking an apple pie once, and I think this is way easier.

The same thing happens if you want to use slanted-line shadowing with a different style font. Just write your letter, outline it, then add the short thin lines to create the shadow effect wherever they would normally fall. Try to keep your lines as consistent in length as possible.

What do you think? This method is definitely more time-consuming than the type of shadowing we've been using up to this point, but it creates a really fabulous and eye-catching effect! You're going to have plenty of opportunity to try it out as you letter your design, because you'll be adding shadows to the words "imagination" and "wings!" Ready to get started?

You'll begin creating your design by drawing a guideline and positioning the word "imagination" on it. Above the word, sketch a long banner (page 16) with the words "the man with no" inside. Below "imagination," draw a guideline and write the words "has no." Use a straightedge to help you draw a box around the words. Finally, draw a line below your box and position the word "wings" on it. Once everything is in place, it's time to go back to your markers. Trace the first and third lines of text with a fine-tip black marker, adding embellishments to the banner and box if you like. Then, use a thicker colored marker to write the rest of the words. Trace the letters with your fine-tip black marker, then finally add the slanted-line shadowing we just learned to finish off your design!

BRUSHING UP

By now, you're well acquainted with brush technique, but up to this point, we've been practicing it using markers. In reality, though, brush lettering started as an art form done with an actual paintbrush as the main tool. So how does using a brush differ from what we've already learned? Honestly, it's a very similar skill, just more challenging because the brush gives us less control than a marker does. The tips of brush markers are designed to be easily manipulated to create just the effect an artist wants, while a real brush has bristles that sometimes have minds of their own. Although it may feel strange and different at first, it's worth trying your hand (quite literally) at using a brush. Some artists find that they ultimately prefer markers for their everyday projects, while others really take to the brush and use it often. Let's take a look at some tips for brush use and you can experiment to find out which type is best for you.

AS LONG AS EVERYTHING IS EXACTLY THE WAY I WANT IT, I AM TOTALLY *flexible*

CONTROL ISSUES

I confess, I've never been good at group work. My school career was filled with experiences where I volunteered to do almost everything for a group project because I wasn't comfortable depending on my partners' efforts (or lack thereof) for my grade. Even though it meant more work for me, I knew it would be done to my own standards. Even today, while I'd happily let someone else do some of my jobs like cleaning the bathroom, there are certain things I want done my way or not at all. I think all of us have particular things in our lives like that. The truth is, though, there's an awful lot in life that's beyond our control. We can do our best to guide them, but we can't determine who our children will become. We don't get to prevent things like natural disasters or diseases. Part of learning to fully enjoy life means we have to learn to be okay with the fact that we're not in charge. We can't always choose what happens to us, but we can choose how we react. We do have control over our own actions and words, and how we use them can have an impact far beyond what we can imagine. Instead of worrying about who's in the driver's seat today, focus on controlling your reactions to the things that happen to you. Will you choose to smile? To forgive? To be grateful?

One thing you can try to control, though, is your paintbrush. Let's take a look at how to use it to create beautiful lettering!

BRUSH-TECHNIQUE WORKSHOP

I love quotes that make me laugh, so I couldn't resist choosing this one, spoken by Lorelai Gilmore in the popular series *Gilmore Girls*, for today's topic. Lettering with a brush takes time and patience, so we're going to use it just for the word "flexible," while the rest of the quote is in a simple print.

Before we tackle the design, though, we have to start with the technique. This requires some different materials from most of our other workshops. First, you'll need a small script/liner paintbrush, which is a pointed, narrow brush with very long hair. You'll also need paints, preferably watercolors. If you don't already own watercolors, there's no need to invest in a ton of expensive supplies. Just grab a basic pack from your local craft store and it'll do the trick.

The basic skills you've been practicing all along for brush technique (page 81) are the same things you'll do now, just with different media. Let's start by creating some downstrokes. Hold your brush at a 45-degree angle to the paper and use a bit of pressure. Too much pressure will cause the bristles to fan out, which you don't want. Just use enough pressure to create a nice thick line.

Continue practicing these downstrokes. They won't look identical, and you can already see that controlling the brush can be a bit tricky, but just try to get a similar look to your lines.

Now practice making some upstrokes. Just as you would with the pen, hold the brush at more of a 90-degree angle to the paper and use very little pressure at all. You want to create a line that is lighter and thinner than your downstrokes.

Try alternating your down and upstrokes, then see if you can create some of the other practice exercises we did with our pens (see page 82).

You already know how brush letters work and where the respective down and upstrokes are, so as soon as you feel comfortable with creating the strokes, you're ready to try the alphabet. Remember, it won't be perfect at first. It can be frustrating trying to make the brush do what you want it to do, but in time, if you work with it more, it will become second nature.

Practice forming some individual letters, then try connecting them to form short words. Work your way up to writing the word "flexible," then you're ready to letter our quote! You may find that you absolutely love working with the brush and want to focus your energy on developing this skill. Or, you may discover that you're a marker and pen artist, which is what happened for me. Either way, it's always good to try something new and see where it takes you!

DIGITIZING YOUR LETTERING

Friend, can you believe how far you have come? You are well on your way to being a lettering expert! Now that you've created a variety of hand-lettered designs, what are you going to do with them all? I know that for me personally, part of the fun of creating art is being able to display it, whether that's as a meme on social media or on something physical like a T-shirt, coffee mug or tote. So how do we take a hand-lettered piece and turn it into one of those things? It all starts with the process of digitizing. We have to get the art off the page and onto the computer, where it can then be turned into just about anything. This final workshop will walk you through the basics of taking your art to the next level as a digital file, because from there, the possibilities are endless!

THIS DIGITAL WORLD

As I type these words, digital radio is playing in the background and the occasional notification lets me know I've gotten a message or sold a shirt in my online shop. My son and his friends are entertaining themselves by making stop motion videos on a tablet. Every single thing that's happening in our house right now is digital except for the cat's nap. That's the world we live in today. Electronics have been part of my son's childhood in ways I could never have imagined when I was his age, and I find myself pursuing a career that didn't even exist when I was exploring my options in high school. Whether we like it or not, there's an increasing need to be proficient with technology in order to do even the most basic tasks. Perhaps that's why it's so important to so many of us—and so therapeutic too—to hold on to projects done with our own two hands. Practicing hand lettering and other types of crafting connects us to a reality that goes beyond a screen. No matter how digital everything around us becomes, we can continue to value craftsmanship and take the time to master new skills we'll still be able to employ even if the computer crashes or the power goes out. What are some of your favorite non-digital hobbies to pursue?

I sure hope, friend, that lettering is on your list! Let's finish up our journey together with one last workshop, creating and then digitizing your design.

I WON'T BE *impressed* WITH *technology* UNTIL I CAN *download coffee.*

DIGITIZING WORKSHOP

The design we'll be lettering today combines brush lettering (page 100) and Whimsical Print (page 24), along with a simple coffee-cup doodle. Before we can digitize our art, we have to create it, right? Spend some time lettering this fun quote about technology, then continue with the tutorial to see how you can take it off the page.

The first step to digitizing your artwork is to get it from the paper to your computer. Depending on what resources you have available, there are several ways to do this. The best option is to use a good scanner. A scanned image will be the closest thing to the real piece of art, as far as color and quality. You'll want to scan your image at 300 dpi or higher so it's as clear as possible.

If you don't have access to a scanner, your other option is to take a digital photo of your artwork. A DSLR camera is preferable, but if all you have is your phone, it'll suffice. Place your lettered piece on a flat surface in natural light, then snap your photo. I like to take several photos in case one gets blurred, then I can choose which one turned out best.

Once you have a digital image of your lettering, you're ready to edit. Typically, I like to use the website Pic Monkey (picmonkey.com) as an editor because it's free and can do the basic edits I need for most projects. Black-and-white projects are the easiest to edit. Here are the steps I follow:

STEP 1

Adjust the saturation to -100 or whatever setting on your editor makes the image black and white.

STEP 2

Adjust the highlights as high as they go.

STEP 3

Adjust the shadows until you're pleased with the contrast and the look of your image.

If you feel as though you need to make additional edits, feel free, but those few steps usually do what it takes to get a bright, crisp image.

If you're working with a colored image, you'll first want to check the white balance. If your image is scanned, it's probably correct, but photos can be off by a good bit. Play around with adjusting the brightness, highlights and shadows until you like the way the image looks.

With your digital file now edited, it's ready to use in whatever way you like. You can upload it to a website like Shutterfly or Zazzle to have it turned into just about any type of product you can imagine. Another thing you can do with the digital file is use it as an overlay for a photo. The sky's the limit! Just imagine all the things you will create as you continue to explore this new hobby!

Take a few minutes to sketch out this final design in the practice space below, then create your finished masterpiece on the doodle page. Once it's completed, scan or photograph it and follow the steps in the tutorial to turn it into a digital image you can use anywhere.

Friends, we've come to the end of our lettering journey together, and I truly hope that you enjoyed the experience. It's been a pleasure to guide you through the basics of hand lettering for relaxation. Over the course of these workshops, you've learned a variety of font styles, lettering techniques and embellishments that you can put to use as you create beautiful designs of all kinds. There's no limit to what you can do with this new hobby, and there are lots of ways you can continue to develop your skills. Pinterest and Instagram are great sources of design inspiration, and you can learn new techniques from blogs, other books and even hands-on classes in your area. I'd love for you to check out the lettering tutorials on my blog and join my One Artsy Mama & Friends Facebook group so we can stay in touch. Wherever you go from here, remember our motto: practice makes progress. The more you try, the more you'll achieve. I just know you're going to create wonderful designs.

ACKNOWLEDGMENTS

Writing a book is no small endeavor, and I am indebted to the people in my life who made this possible with their support, expertise and assistance. I'd like to say a special thank-you to . . .

Erin Kerst—My right-hand gal who also happens to be my best friend. Thank you for your incredible organization skills, for hours of scanning images and for constantly keeping me focused on the end goal. We both know I couldn't have done this without you.

Dan—For unconditional love and support and putting up with a giant mess in the house while I was busy creating. When I first started this journey and felt like I could never succeed, you challenged me to figure it out. I think I did.

Noah—You were a great sport, understanding that Mommy needed extra time to work for a few months so this book could happen. I love you to the moon and back.

Mom & Dad—Thank you for always believing I could do anything and making me start to believe it too. I love you.

Stephen Kerst—Hats off to the official tech support of One Artsy Mama!

Joe—I cannot thank you enough for rescuing me from the scanning disaster and converting all those files so I didn't have to start over.

Gwen—Thanks so much for the technical assistance with revisions!

Will, Sarah and the rest of the Page Street crew—Words can't express what it means to me that you believed in my ideas and helped make this dream a reality. Thanks for the really cool scanner, too.

Lisa—For listening to me "wine" and for good talks that inspire me every time.

Amy Anderson—For pointing me in the right direction with my book proposal and sharing your author expertise along the way.

Dawn Nicole Warnaar—For inspiring me to begin hand lettering in the first place. Thank you for your guidance and friendship.

Sarah Hodsdon—My beloved mentor who saw something in me the first time we met that I still have trouble seeing in myself.

Tombow USA—For partnering with me, supporting my artistic endeavors and allowing me to be a brand ambassador for a line of top-quality products I truly love.

Plaid Crafts—For your unfailing support of my creative journey and allowing me to be part of the Plaid family.

My Readers and Members of the One Artsy Mama Community—Without you, there would be no book, no blog, no business. You are the heartbeat of what I do every day and the reason I created this guide. I hope you enjoy it and know that it's all for you.

ABOUT THE AUTHOR

Amy Latta, a.k.a. One Artsy Mama, is passionate about inspiring her online community by sharing honest inspiration for everyday life. On her blog, you can find craft and DIY projects anyone can create! Amy is happiest when crafting and, when she's not covered in paint, you can find her working on professional design collaborations. Her original hand-lettered designs have been featured nationally in Starbucks and GAP stores. You can also find her designs on apparel, home décor and more in her shop Coffee & Tee Designs. Amy is the recipient of The Craftys' 2015 "Best Craft Blogger" award, as well as being voted the top Crafty Blogger of 2015 in the SwayyEm community. In her spare moments, you can find her spending time with her family and drinking lots and lots of coffee.

INDEX